THE BIRTHPLACE OF
PROFESSIONAL FOOTBALL
SOUTHWESTERN PENNSYLVANIA

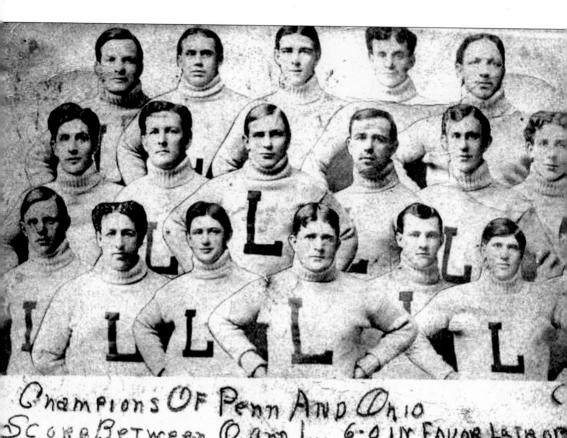

Champions OF Penn And Ohio
Score Between O and L. 6-0 in Favor Latrobe

By 1905, Latrobe had one of the dominant teams in all of football, as it went 26-0 over a three-year period. In the picture shown above, Latrobe claimed the Pennsylvania and Ohio championship after defeating a club 6-0 from an Ohio town that half a century later would defeat them for the rights to build the Professional Football Hall of Fame: Canton. (Courtesy of the Latrobe Historical Society.)

THE BIRTHPLACE OF
PROFESSIONAL FOOTBALL
SOUTHWESTERN PENNSYLVANIA

David Finoli and Tom Aikens

ARCADIA

First published 2004

Published by Arcadia Publishing,
Charleston SC, Chicago IL, Portsmouth NH, San Francisco CA

Printed in Great Britain

Library of Congress Catalog Card Number: 2004108650

For all general information, contact Arcadia Publishing:
Telephone 843-853-2070
Fax 843-853-0044
E-mail sales@arcadiapublishing.com
For customer service and orders:
Toll-free 1-888-313-2665

Visit us on the Internet at www.arcadiapublishing.com

From David: For my wife, Viv, and my three children, Matthew, Cara, and Anthony, whose support helps make my writing career a reality.

From Tom: To my children, Elizabeth, Benjamin, and Catherine.

Also dedicated to the memory of Elizabeth Finoli Duffner, our beloved aunt who passed away during the writing of this book.

CONTENTS

Acknowledgments

First and foremost, we would like to thank Carl Mattioli and the entire Latrobe Historical Society staff for their incredible generosity and the time they gave to complete this project, without which we never could have published this story.

John Howard, who runs the Jeannette Historical Society, was a great help in providing research and photographs of the Jeannette Indians club of the mid-1890s, as well as Pete Fierle from the Professional Football Hall of Fame. Clay Luraschi and the Topps Card Company have been a great help in every project we have undertaken, including this one.

Finally, we have been lucky enough to enjoy the wonderful support of our families throughout our lives. A huge thank-you goes to Tom's mother, Evie; the memory of his father, Tom; his sisters, Amanda and Claudia; and to David's mother, Eleanor; his father, Domenic; his brother, Jamie; his sister, Mary Louise; his in-laws Salvatore and Vivian Pansino; as well as all our nieces, nephews, aunts, uncles, and cousins.

Bibliography

BOOKS
Carroll, Bob, and Bob Braunwart. *Pro Football: From AAA To '03*. North Huntingdon, Pennsylvania: PFRA, 1991.
Nakles, Ned, ed. *Latrobe Zimbos 1946–1950: A Recollection*. Self-published.

WEB SITES
The Professional Football Hall of Fame: www.profootballhof.com
The Diamond Angle: www.diamondangle.com
The Millwood Shaft Mine: www.patheoldminer.rootsweb.com/millwood.html
The Greater Latrobe: www.greaterlatrobe.net
The Professional Football Researchers Association: www.footballresearch.com

PERIODICALS
Around Latrobe. Myers, E. Kay. "Latrobe: Cradle of Pro Football," August 22, 1997.
Sport
The *Chicago Tribune*
The *Latrobe Bulletin*
The *New York Times*
The personal papers of Dr. John Brallier
The *Pittsburgh Gazette*
The *Washington Post*

INTRODUCTION

It started as an act of desperation and inevitably turned into one of this country's most revered pastimes: professional football.

Club football at the end of the 19th century was thriving, especially in the small towns that dotted the hills of the Allegheny Mountains in southwestern Pennsylvania. It was as exciting as it was pure, with nothing but amateurs. Being paid to play football was not only considered unethical, but to many it represented a risk to their amateur status.

In Westmoreland County, football flourished in cities such as Greensburg and Jeannette, prompting the town in nearby Latrobe to get into the act in 1895 and form a team that represented the local YMCA. The manager of the club was a man by the name of David Berry, who was also the editor of the *Latrobe Clipper*. Berry was faced with the prospect of opening his inaugural campaign on September 3 against Jeannette without the services of his quarterback Eddie Blair, who had a previous commitment to play baseball for Greensburg. Remembering a 16-year-old high school quarterback in nearby Indiana by the name of John Brallier, Berry set out to secure his services to replace Blair.

At first, Berry offered to pay the young signal caller's expenses to play for his team. When Brallier turned him down, the aggressive manager sweetened the offer by giving him an additional $10 on top of the expenses. At the time, $10 was too much money to turn down, and Brallier accepted his offer. The $10 turned out to be well worth the money, as the quarterback led Latrobe to two touchdowns in a 12-0 opening-day shutout against Jeannette. The payout was also important in the fact that it made John Brallier the first professional player in the history of the sport.

For his part, Brallier wore his title proudly. He took the money he earned from the game and purchased a pair of pants that he took with him to Washington and Jefferson College, where he of course played football. Later, he became a successful dentist who openly admitted that he had been given money to play the sport.

While many suspected others had been paid, Brallier was the only one to make the claim. Because of this, the National Football League (NFL) officially recognized the dentist as the first professional player and gave the town of Latrobe the official moniker "Birthplace of Professional Football." On top of the title, the small town was also given the rights to construct the Professional Football Hall of Fame. It was the top of the roller coaster for Latrobe, as things would soon fall apart very quickly.

The NFL was not the sports power that it is today, and they could not afford to pay for the hall of fame. It was up to the Westmoreland County municipality to raise the funding to build the football mecca. After almost a decade of trying, Latrobe was unable to come up with the money, causing the NFL to take other bids to see if anyone else could subsidize the facility. Eventually, Canton, Ohio, emerged as the most viable candidate and received the bid in 1961 to the chagrin of the citizens of Latrobe.

If nothing else, the scenic town was still the official Birthplace of Professional Football, a designation that Dr. John Brallier took to his grave proudly. Fortunately, he died before a document was discovered in the early 1960s, an expense sheet from the Allegheny Athletic Association (AAA), showing that an All-American from Yale by the name of William "Pudge" Heffelfinger was paid $500 by the AAA for a game they played against the Pittsburgh Athletic Club (PAC) on November 12, 1892.

The PAC and AAA were two of the most dominant football teams of their day, and the rivalry between the two was on par with the Steelers and the Raiders in the 1970s. Looking to get an edge, both teams went out in search of talent, focusing on three players: Heffelfinger, Knowton Ames, and Ben "Sport" Donnelly. All three men played for Chicago, and all were disgruntled with their team for giving into the demands of the New York Crescents, who did not want Donnelly, a notoriously dirty player, to play in a game against them.

While the PAC went to the Windy City to try and lure them to Pittsburgh, the AAA found them in New York City and convinced Heffelfinger to come with them for $500 plus expenses to play the PAC on November 12, along with Donnelly, who was given $250 the week after to play against Washington and Jefferson College. The investment was worthwhile; Heffelfinger ran 35 yards with a fumble for the games only score in a 4-0 victory (touchdowns were worth only four points at the time).

The discovery of this expense sheet almost 70 years later proved that Heffelfinger was in fact the first professional player as he received his pay three years earlier than Brallier did. Why did it take so long to find this out? Mainly because Heffelfinger was not proud of the fact he took money to play football, and he went to his grave never admitting this ever happened. Brallier was simply the first the player ever to admit he took money to play the game.

Despite the fact the birth of professional football actually took place in Pittsburgh three years earlier than originally thought, it certainly does not diminish Latrobe's spot in the annals of the professional version of the sport. After all, they not only had one of the top squads in the area annually, but they fielded the first all-professional team in 1897, a fact alone that legitimizes their claim as the Birthplace of Professional Football. This book not only tells the tale of the origins of what is now the national pastime, but it celebrates the contributions Brallier and this quaint city in Westmoreland County made to the beginning of professional football. It also features the towns in Westmoreland County at the turn of the century, including Latrobe's ill-fated bid to secure the hall of fame.

One

THE CITIES

In the modern world of home entertainment, it is difficult to remember that at the turn of the century, entertainment was a community affair. People gathered in social clubs, theaters, and athletic fields and had to leave their homes in order to be entertained. This was especially the case as Americans continued to migrate from rural life to urban settings.

Westmoreland County in the late 1890s was still a very rural place. The county was mostly farms. Its industries were agriculture, coal, coke production, and the start of the intense manufacturing base that would be the hallmark of the community through the 20th century.

The population that did not live on farms or the "coal patches" lived in a number of burgeoning urban areas scattered across the county. The county was dotted with small cities that were fairly self-contained, having their own newspapers, stores, and manufacturers.

These were not easy times to live. Public facilities were primitive, horses still competed with automobiles for space in the streets, and the rules of the workplace had not yet been modified by organized labor.

In central Westmoreland County, the cities were Latrobe, Greensburg, and Jeannette. Greensburg was the county seat and contained the county government and courts, as well as large local banks and the legal community. Fifteen miles down the Lincoln Highway was Latrobe, at the foothills of the Laurel Ridge of the Allegheny Mountains. Five miles to the west was Jeannette, only then beginning to develop the industry that would later give it the name "the Glass City."

The growing populations of these cities were looking for more things to do with their time. In the 1890s, club football in these cities became a new form of entertainment, sort of a local example of the much more popular college game. They competed with long-distance bicycle races for the citizens' attention.

Games were occasionally preceded by parades, as brass bands escorted players and fans to the field of play. The stands in the heyday of the club game would be full of at least 1,000 fans. For one Greensburg-Latrobe game, a newspaper estimated 5,000 people were present. These fans filled stands that would barely pass as high school football stadiums these days.

One source for this information are copies of stories from the defunct *Latrobe Clipper*, edited and published by Dave Berry, the owner and manager of the Latrobe club. While these columns obviously had promotional value, it is also clear that football was a community event of great

importance. Latrobe's first game versus Jeannette on September 3, 1895, began in just such a way, according to Berry.

"Promptly at 4 p.m. both teams gathered at the corner of Ligonier and Main streets and headed by the peerless Latrobe Cornet Band, the parade proceeded on its way to the ball park," he wrote. The first game between Latrobe and Greensburg, according to Berry, "was the greatest game of football ever played in the county."

However, as is typical today, many rabid sports fans of the late 19th century felt the need to improve the game with side wagers. Berry makes repeated references to the gambling action on a big game. Discussing one of the great 1898 games against Greensburg, Berry sets up his crown of victory by being glad that Greensburg residents had good credit in their shops because the club supporters were out of cash after betting on a hometown victory.

Years later, when the Latrobe club traveled to Steelton for a major game, Berry's newspaper projected the score and game summaries on a screen outside the *Clipper*'s office. The story said Latrobe went wild with excitement after their club's victory.

Club football flashed on the scene and then passed as attention returned to the bigger college game. The legacy it left behind was that the game could exist outside colleges, just as college football had to grow beyond the eastern colleges eventually to the service academies and the large state universities.

The spread of club football west to Ohio formed the embryo of what was eventually to grow into professional football. That original organization was the child that grew to be the man: the multibillion-dollar NFL of today. Disputes over what town hosted the first paid football player, a bit of trivia at best considering the years and changes to the professional game, is a testament to its strength today.

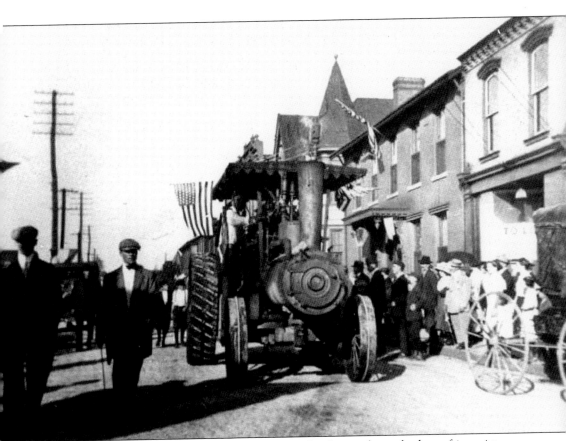

Agriculture was one of the main industries in Latrobe during the early days of its existence. Pictured here is an early tractor parading down the streets of the Westmoreland County city. Notice the horse-drawn carriage to the right. (Courtesy of the Latrobe Historical Society.)

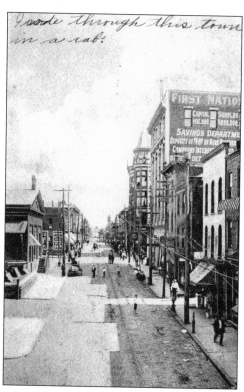

I rode through this town in a cab.

Here are two photographs of Ligonier Street, Latrobe's main street, in the 1890s and the early 20th century. It was the center of the town's financial and commercial activity at the turn of the century. Ligonier Street was also the starting point for parades before quite a few Latrobe club football games in the 1890s and early 1900s. A band would lead the two teams into battle at YMCA Field. (Courtesy of the Latrobe Historical Society.)

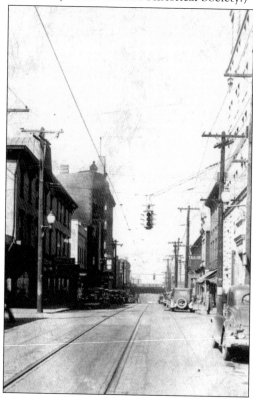

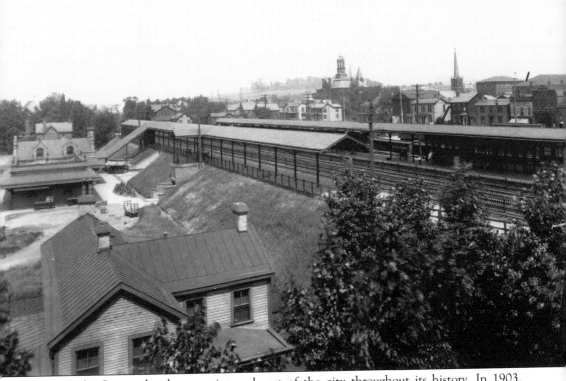

The Latrobe Station has been an integral part of the city throughout its history. In 1903, 52 years after the land was purchased, the station was constructed, allowing Latrobe to become an important industrial town as well as a stop for passengers traveling throughout the East Coast. By the 1970s, the station had fallen into disrepair. A decade later, in 1986, it was restored and given landmark status in the National Register of Historic Places. Today, it still operates as an active train station and is the home to a favorite local restaurant. (Courtesy of the Latrobe Historical Society.)

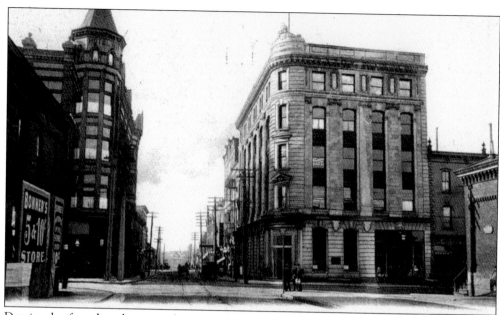

Despite the fact that they were bitter rivals on the field, Latrobe and Jeannette had a lot in common. Pictured here is Latrobe's Depot Street, where the Miller Hotel and the First National Bank were located. The Miller Hotel was built in 1889 at the corner of Ligonier and Depot Streets and, in later years, also served as a bus depot. (Courtesy of the Latrobe Historical Society.)

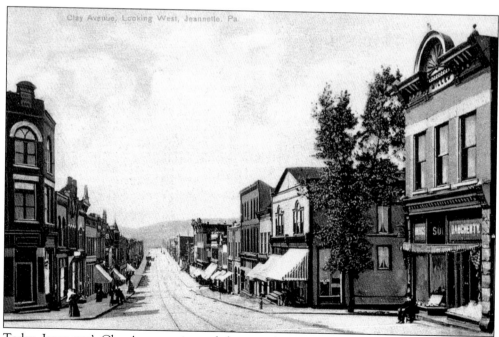

Today, Jeannette's Clay Avenue, pictured above, is the center of the city's shopping district. In the 1890s, Jeannette's Magee Avenue, a few blocks away, was the main thoroughfare due to its proximity to the train station. (Courtesy of the Jeannette Historical Society.)

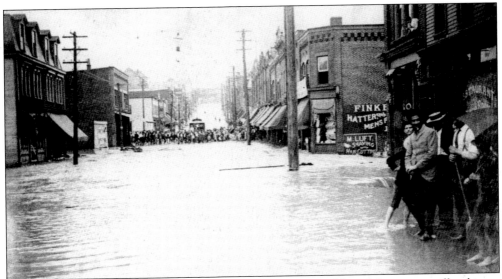

Both cities had creeks nearby and both experienced flooding, although Jeannette suffered more damage than Latrobe, culminating in the Oakford Park Flood, which killed as many as 20 people. The picture here shows flooding at the bottom of Clay Avenue, the part of the city that was most often damaged by the floods. (Courtesy of the Jeannette Historical Society.)

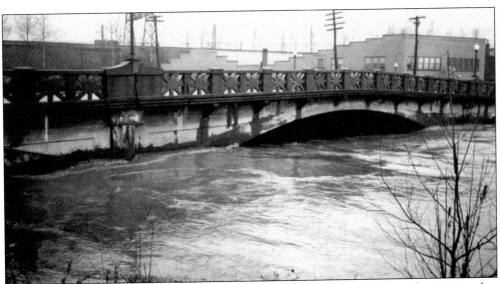

The Loyalhanna Creek runs at flood level through Downtown Latrobe. Latrobe is situated at the foothills of the Laurel Ridge (where the Loyalhanna runs), part of the Allegheny Mountain chain. (Courtesy of the Latrobe Historical Society.)

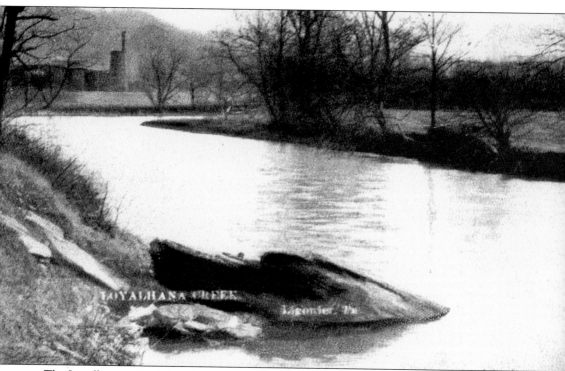

The Loyalhanna Creek is an important tributary in the local river system. It begins in southern Westmoreland County, flowing northeast through nearby Ligonier and Latrobe and joining the Conemaugh River in Saltsburg, which forms the mighty Kiskiminetas River. The Loyalhanna has been a favorite spot of Westmoreland County's outdoorsman and swimmers for years, especially during one of the most important days of the local outdoor sportsman's calendar: the beginning of trout season. (Courtesy of the Latrobe Historical Society.)

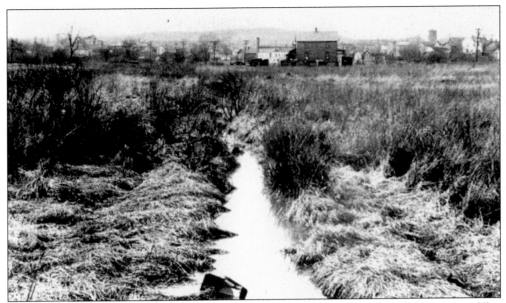

In the 1890s, it was often hard to discern the boundary between the city and the country. This is a picture of a farmland very near the residential area of Latrobe, shown in the background. (Courtesy of the Latrobe Historical Society.)

The farming industry was the dominant element of the Latrobe economy at the turn of the century. Pictured here is the farm of J. McBride, one of the largest in the area at the time. (Courtesy of the Latrobe Historical Society.)

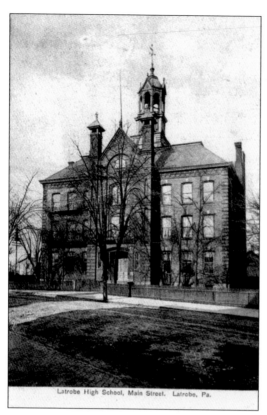

Latrobe High School, Main Street, Latrobe, Pa.

Latrobe Senior High School was originally built in 1914 as a small one-building schoolhouse. In 1936, an addition was built to house the ever growing population in the city. Eventually, in 1966, a much bigger campus was constructed a few miles away, the same high school that is currently used. The small building, which housed the high school for 52 years, was used as a middle school in 1966 before being turned into the junior high and then an elementary school in the Latrobe Area School District, of which it remains today. The Latrobe Historical Society is also housed in this building. (Courtesy of the Latrobe Historical Society.)

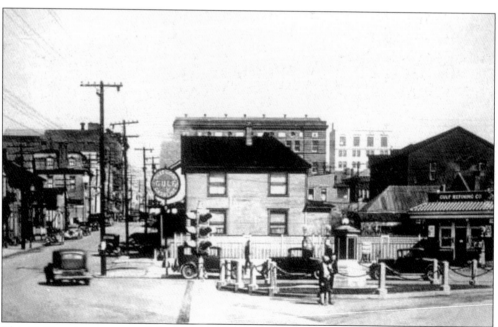

This Gulf station was one of the first gas stations in Latrobe as automobiles began to compete with horse-drawn carriages and streetcars down the city's many streets. (Courtesy of the Latrobe Historical Society.)

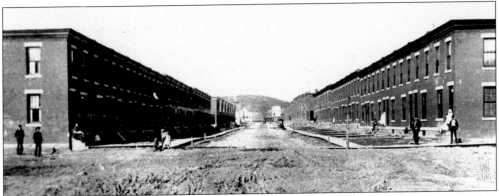

Pictured are Jeannette's distinctive row houses built behind the Chambers-McKee Glass Company on Fifth and Sixth Streets. They were used to house the employees of the plant. The row houses are still in use in the city today. (Courtesy of the Jeannette Historical Society.)

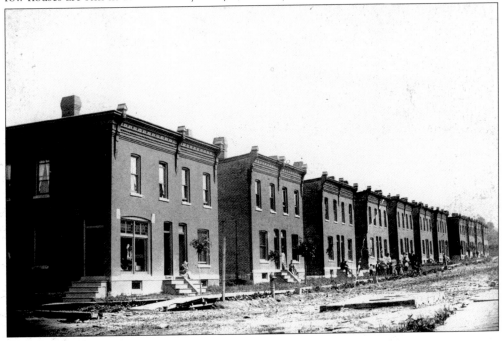

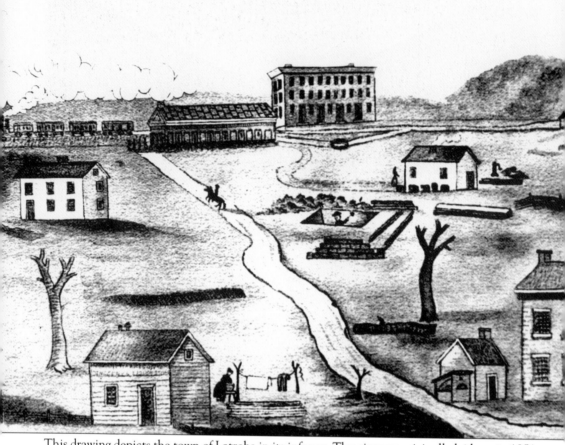

This drawing depicts the town of Latrobe in its infancy. The city was originally laid out in 1851 by Oliver Barnes, a civil engineer for the Pennsylvania Railroad. Barnes purchased a 140-acre farm and donated 3 acres for the railroad and streets. He named his town for Benjamin Latrobe, a friend who was an architect and the son of one of the greatest architects in American history, Benjamin Latrobe Sr. (Courtesy of the Latrobe Historical Society.)

In the early 1900s, T. A. Cebula's shop was the place to go for a variety of things, such as sporting goods and musical instruments. The clock outside of his store was a landmark in town. (Courtesy of the Latrobe Historical Society.)

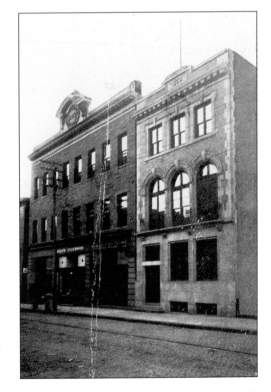

Pictured to the right is the old city hall in Latrobe, which was housed next to Ralph Anderson's drugstore, one of the preeminent stores in Latrobe at the time. (Courtesy of the Latrobe Historical Society.)

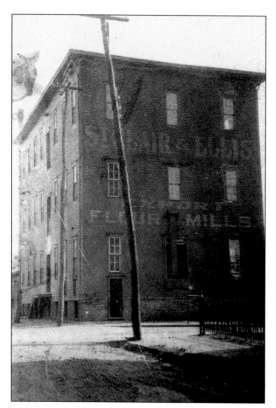

The St. Clair and Ellis Export Flour Mill and the N. J. Gartmann and Company Wholesale Bakery and Ice Cream Manufacturer on Ligonier Street were two of the prominent businesses in Latrobe in the early 20th century. (Courtesy of the Latrobe Historical Society.)

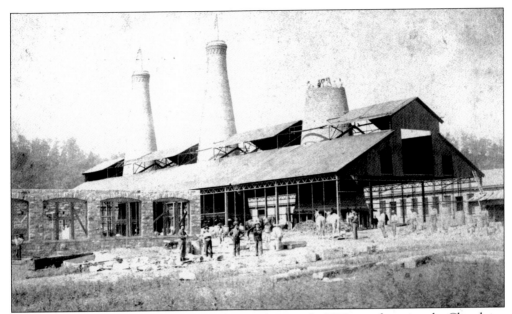

Jeannette's industrial fame was built on glass production. In 1888, two factories, the Chambers-McKee Glass Company and the American Window Glass Company, both began their operations. This picture shows the Chambers-McKee Glass Company as it was being constructed. (Courtesy of the Jeannette Historical Society.)

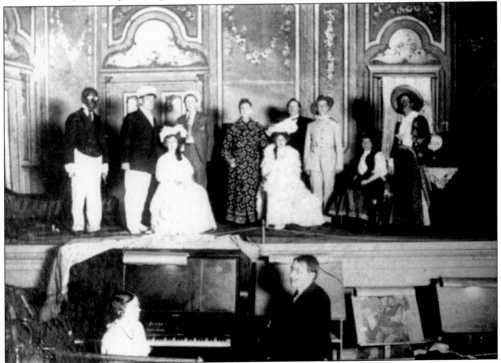

The Showalter Opera House began operation in Latrobe in 1884. The opera house, which was located on Depot Street, was home to many outstanding shows throughout its duration. (Courtesy of the Latrobe Historical Society.)

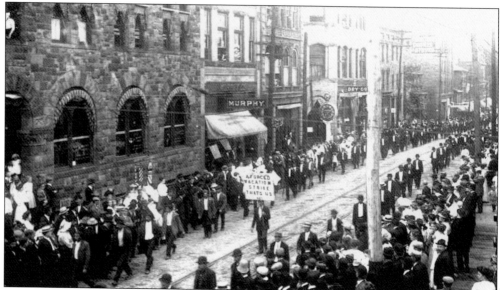

In 1910, coal miners in Westmoreland County were embroiled in a strike. During the impasse, violence erupted as the water tanks in the Latrobe-Connellsville Coal and Coke Company's Millwood Mines were dynamited by an unknown perpetrator. As these pictures show, the striking miners paraded down the streets of Latrobe to rally in support of their cause. (Courtesy of the Latrobe Historical Society.)

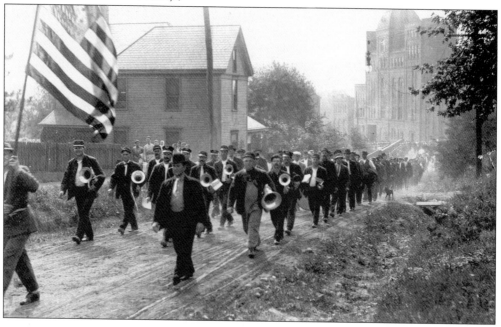

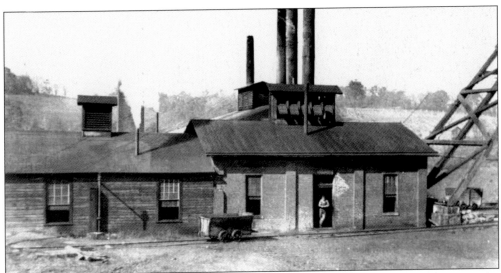

In 1872, the Millwood Shaft mine was open for business about seven miles east of Latrobe. The mine was owned by the Millwood Coke and Coal Company, who kept the corporation until 1906, when it was sold to Latrobe-Connellsville Coal and Coke Company. Shown here is the engine house at the facility. (Courtesy of the Latrobe Historical Society.)

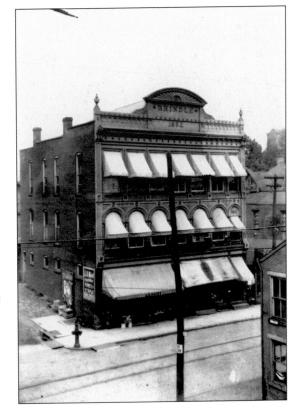

Latrobe's Brindle Building was built in 1892 on Eastern Street. The J. A. Maier grocery store, the Latrobe Coffee Company (also known as the Butter Store), and the offices of Dr. Ober all were occupants of the structure. The Brindle Building was demolished in 1935 and was replaced by several gas stations. (Courtesy of the Latrobe Historical Society.)

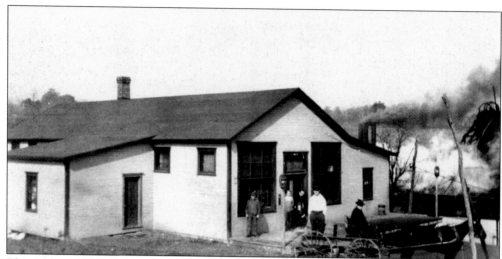

This is the Millwood Coke and Coal Company store. The shop was for the use of company employees and family, who were forced to use the store instead of the less expensive facilities in town. The miners and their families could buy everything here, including clothing and food. (Courtesy of the Latrobe Historical Society.)

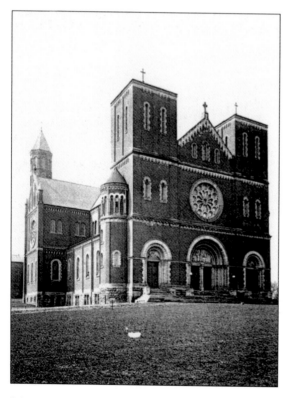

For a small town, Latrobe has more than its share of landmarks, including St. Vincent College and the St. Vincent Basilica (shown here). Benedictine Father Boniface Wimmer came to St. Vincent in 1846 and founded the first Benedictine monastery in the United States. The Benedictines ran St. Vincent College as a preparatory school shortly after the Civil War, and it grew to a four-year liberal arts college. St. Vincent's also has a football history. Along with having a strong college program for some years, it also annually hosts the NFL's Pittsburgh Steelers summer training camp. (Courtesy of the Latrobe Historical Society.)

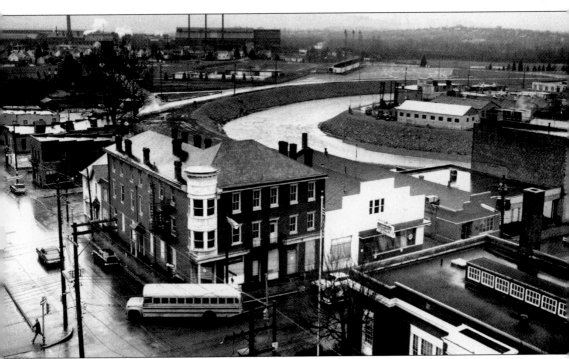

The Nixon Hotel is shown above in the 1950s. The hotel was a landmark in the city, known by no less than four names in its long and illustrious history. In 1903, it was built as the Union Hotel before becoming the Heinz Hotel. It was sold and renamed the Vogel Hotel. After being sold once again, it became the Nixon Hotel, the final name of the building. In 1978, following 75 years of service to the city, the Nixon Hotel was torn down. (Courtesy of the Latrobe Historical Society.)

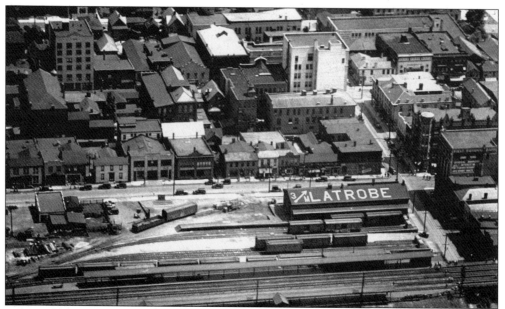

By the early part of the 20th century, Latrobe had grown significantly from its original rural setting. This aerial shot, taken in the early 20th century, shows just how much the city had grown. Notice the "Latrobe 3 mi" sign. This was used in the early days of aerial navigation to show pilots where the airport was located. (Courtesy of the Latrobe Historical Society.)

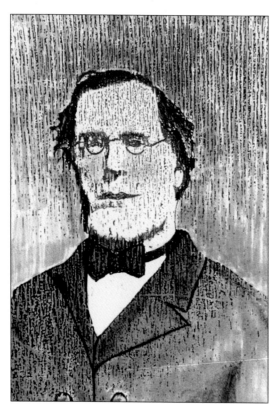

This portrait is of Benjamin Latrobe Jr., for whom the town of Latrobe is named. Oliver Barnes actually founded the city but named it for his friend and classmate. Latrobe was a civil engineer for the Baltimore & Ohio Railroad and, ironically, never visited the town that was named after him. (Courtesy of the Latrobe Historical Society.)

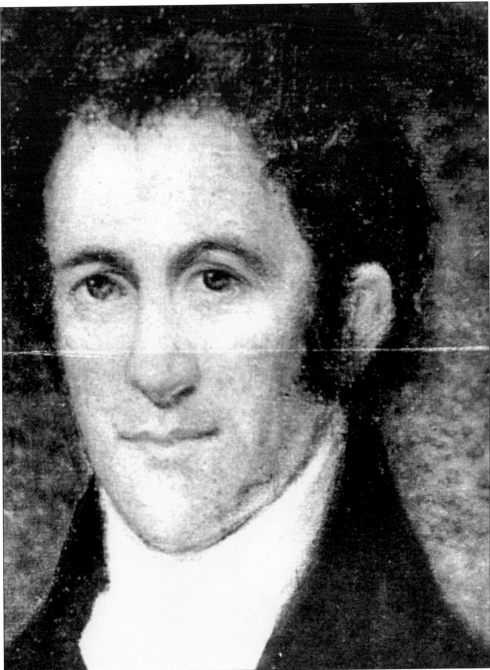

While Benjamin Latrobe Jr. is famous for having the scenic Westmoreland County town named after him, his father, Benjamin Latrobe Sr., was even more renowned. Latrobe Sr. was one of the foremost architects in the history of the United States. In fact, he is known as the first professional architect in this country and had the job of rebuilding the U.S. Capitol on his resume. Latrobe Sr. came to America in 1796, after the death of his wife, and helped design such classic buildings as the Bank of Pennsylvania, the Philadelphia waterworks, and the Baltimore Cathedral. He died in New Orleans in 1820. (Courtesy of the Latrobe Historical Society.)

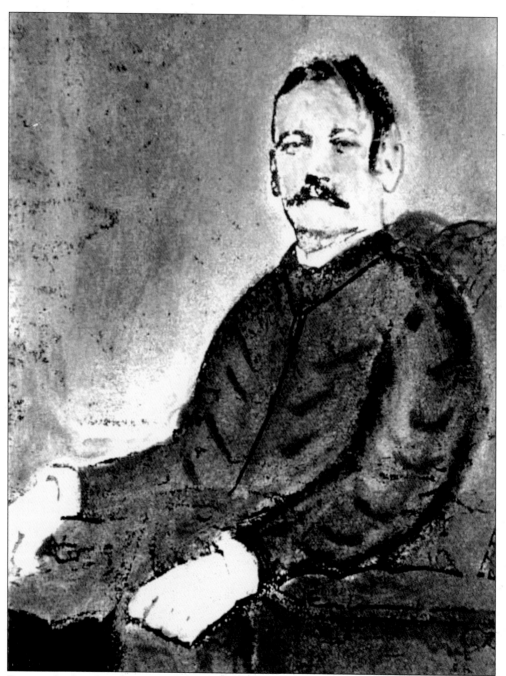

Despite the fact that the town was named for Benjamin Latrobe Jr., Oliver Barnes was actually the founder of the Westmoreland County community. Barnes was also a civil engineer who worked for the Pennsylvania Railroad. He owned land that the railroad ran through and believed because of this that the area could develop into a significant industrial hub, which it eventually did. Barnes donated three acres of his land so that a railroad station and streets could be built there. He laid out the town in 1851, and it was incorporated on May 24, 1854. (Courtesy of the Latrobe Historical Society.)

Two

THE TEAMS

In the late 1800s, Latrobe became involved in the growing passion of local football. The Latrobe club became the first professional team, born out of desperation of a scheduled game coming up and no one to play a key position.

Throughout the 1890s, teams were springing up all over the state and Ohio. In 1894, Latrobe's YMCA chapter decided to start its own club and began gathering players from around the city. The first game was set for September 3 against a team from Jeannette.

Shortly before the contest, Latrobe coach Russell Aukerman learned that his quarterback could not make it to the game. Remembering he had seen an impressive high school quarterback, manager Dave Berry and Auckerman settled on John Brallier, from Indiana Normal School (now Indiana University of Pennsylvania) in neighboring Indiana County, as a replacement. For $10 and expenses, after an initial offer of simply covering expenses was rejected by Brallier, the Latrobe club acquired a quarterback and a place in professional football history.

The first game for Latrobe against Jeannette was a major event in the city. Shops closed early and a huge parade was held, led by a band escorting the Latrobe squad to the field.

Latrobe dominated the affair in the first half with one long drive ending in a touchdown, an extra point, and a 35-yard run by Aukerman for a second touchdown. Brallier kicked both extra points. Latrobe then defended its lead through the second half and won 12-0.

The Jeannette game was a good start for Latrobe's season. They played 12 games that year and ended with an 8-4 record. They were shut out by Altoona, defeated Mount Pleasant and Kiskiminitas, were pulverized by a veteran Greensburg team, and lost to West Virginia University.

However, beginning on November 2, Latrobe began a four-game winning streak, defeating Morrellville, Indiana Normal School, Johnstown, and Jeannette in a rematch. Latrobe won the four games by a combined score of 110-0.

They stumbled and lost to Indiana Normal School in a shutout, 28-0, and then faced Greensburg in a November 30 rematch of the October 5 defeat. Greensburg went into the game as the best team in Westmoreland County, needing to defeat Latrobe again to win the county championship.

While Latrobe had an impressive record, some concluded they had beaten second-rate teams, but they had done it without Brallier, who was off to college. With the college season over, Brallier was back for the Greensburg game. Meanwhile, Greensburg entered the game without several of their best linemen. With Latrobe's addition and Greensburg's subtraction, the two squads were better matched than in their previous encounter.

The first half ended without a score, but both teams were brutal in their defense. By the end of the third quarter, it seemed as though the stalemate would last, but a Latrobe running play broke free around the right end. A shocked audience, likely grown numb by the defensive struggle, sat in silence as the Latrobe running back flew 35 yards into the end zone. With a failed extra point attempt, the game ended 4-0. The contest began what were to be many exciting games between the two neighboring Westmoreland County towns.

By 1896, Latrobe had become a power in Westmoreland County football, but the Greensburg club, which regularly competed against Allegheny County teams, still held the edge. Latrobe went 7-3 that year, defeating the Pittsburgh Imperials, Jeannette (80-0), Altoona, the Western University of Pennsylvania, West Virginia University, and Indiana Normal School twice. Two of their three losses, though, were against Greensburg.

The first match on October 31 featured several long drives by both teams who failed to score. By the end of the first half, Greensburg was leading 4-0. In the second half, Greensburg scored again, making the score 10-0. Latrobe was able to score but missed the extra point, and Greensburg won 10-4, with Latrobe supporters complaining about Greensburg's play.

By 1897, Latrobe's club had reached a peak with 10 victories, 2 losses, and 1 tie in a season where they shut out their opponents eight times. Greensburg also had a season of crushing victories and maintained a strong team. It was clear that the two would battle for the county championship.

Meanwhile, both teams were also beginning an arms race, gathering college football stars in an effort to dominate, as well as compete, against Pittsburgh teams. This competition for plays came to a head in the bidding war for "Doggie" Trenchard, whom Latrobe reportedly got for $75 a game. In three years, these teams grew from squads built around boys who were working in the local mills to teams made up of a number of college kids looking for more playing time. Because the Greensburg team had to delay the match as the result of injuries suffered in the previous game, the usual two Latrobe-Greensburg games made up two of the last three games for both teams.

In the first contest, 5,000 people filled Greensburg's football stadium, the largest crowd yet. The first half ended with Greensburg leading 6-0. Latrobe tied the game early in the second half and, late in the game, picked up a fumbled punt and scored again, easily. Latrobe won the game 12-6.

Tensions were running high for the second game played in Latrobe, this time before 2,000 spectators. The Greensburg squad had not appeared in time for the kickoff, and some Latrobe fans wanted the game forfeited; but the Greensburg club showed up just a few minutes later. An argument ensued between a group of Washington and Jefferson College players, and so much time had been wasted that the game was played with shortened halves.

The contest was a seesaw defensive struggle that, like many great games between equal teams, was decided by an error. In this case, the Latrobe club mishandled a punt. Greensburg recovered the ball deep in Latrobe's territory. After three tries, they scored a touchdown and won the game 6-0 and the championship. The 1897 classic contests were the zenith of a rivalry that was the highlight of the period's club football.

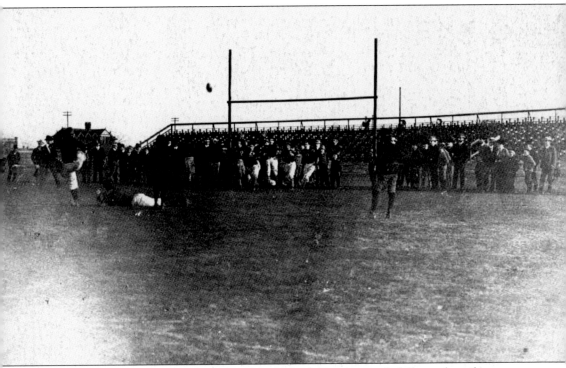

The scoring system in football at the dawn of the 20th century was much different from the game we know today. Touchdowns were four points, while extra points, as shown in the picture above, were worth two. The games were very much a community event. Fans often escorted teams to the field and lined up on the end lines. (Courtesy of the Latrobe Historical Society.)

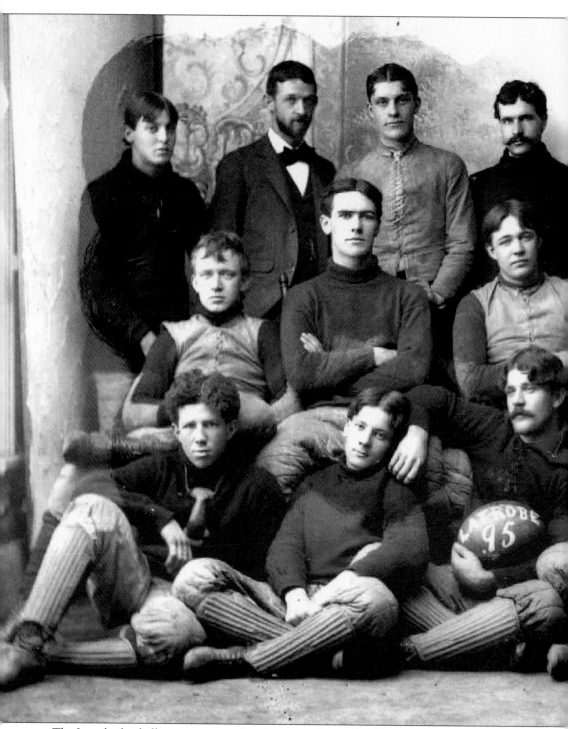

The Latrobe football team was a good as they came during the first years of professional football. In 1895, they also became one of the most important clubs in the history of professional football. Before their first contest on September 3 against Jeannette, manager Dave Berry was left without a quarterback. His starter, Eddie Blair, had already committed to playing baseball

for Greensburg. Berry called on John Brallier (seated third from the right in the front row), whom he enticed to play by paying him $10 plus expenses. Until the early 1960s, when research showed the claim to be incorrect, Brallier was considered the first professional football player. (Courtesy of the Latrobe Historical Society.)

1895.

					
Sept. 3.	Latrobe,	12—Jeannette,	0,		at Latrobe.
Sept. 14	Latrobe,	0—Altoona,	18,		at Altoona.
Sept. 23.	Latrobe,	14 – Mt. Pleasant	4,		at Latrobe.
Sept. 30.	Latrobe,	4—Kiskiminitas	0,		at Latrobe.
Oct. 7.	Latrobe,	0—Greensburg	25,		at Greensburg.
Oct. 19.	Latrobe,	0—W. V. U.	10,		at Uniontown.
Nov. 2.	Latrobe,	36—Morrellville	0,		at Latrobe.
Nov. 9.	Latrobe,	22—Indiana	0,		at Latrobe.
Nov. 16.	Latrobe,	36—Johnstown	0,		at Latrobe.
Nov. 23.	Latrobe,	16—Jeannette	0,		at Latrobe.
Nov. 28.	Latrobe,	0—Indiana	26,		at Indiana.
Nov. 30.	Latrobe,	4—Greensburg	0,		at Latrobe.
	Total,	144.	Total,	83.	

Latrobe had a winning season in 1895, garnering eight wins to go with their four losses. They pummeled Johnstown, Indiana Normal School (now Indiana University of Pennsylvania), and Morrellville and split the series with their archrival Greensburg, getting crushed in the first game 25-0 before winning the second, this time with quarterback John Brallier, 4-0. (Courtesy of the Latrobe Historical Society.)

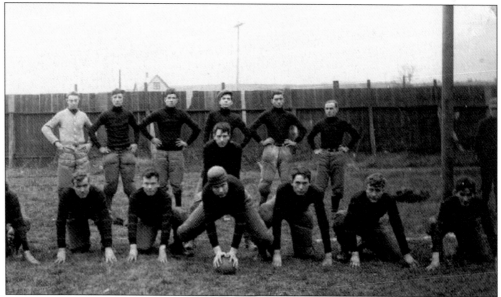

As football grew in the late 19th century, each town seemed to have its own club team to root for. Pictured here are the Oakville Indians. Oakville was eventually annexed to the city of Latrobe and was located where the Fifth Ward is today. (Courtesy of the Latrobe Historical Society.)

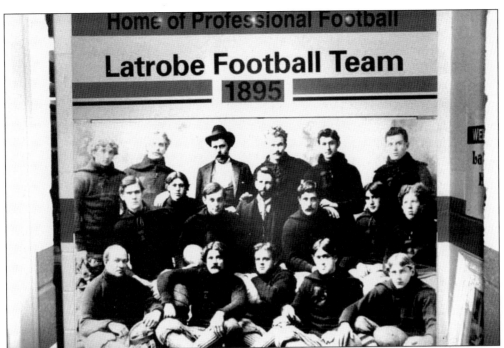

Although college football was the superior game at the time, it was less structured than it is today. Many club teams, such as the 1895 Latrobe club, faced off against collegiate teams. Latrobe played West Virginia University in 1895 and lost 10-0. (Courtesy of the Latrobe Historical Society.)

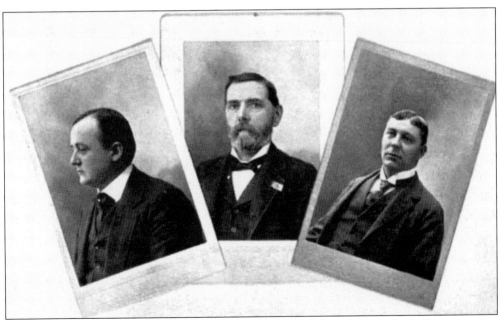

Along with being investors and leaders in southwestern Pennsylvania's football community, E. F. Saxman (left) and W. A. Showalter (right) were also officers in Latrobe's first Elks lodge. Capt. James Peters (center) was an investor. (Courtesy of the Latrobe Historical Society.)

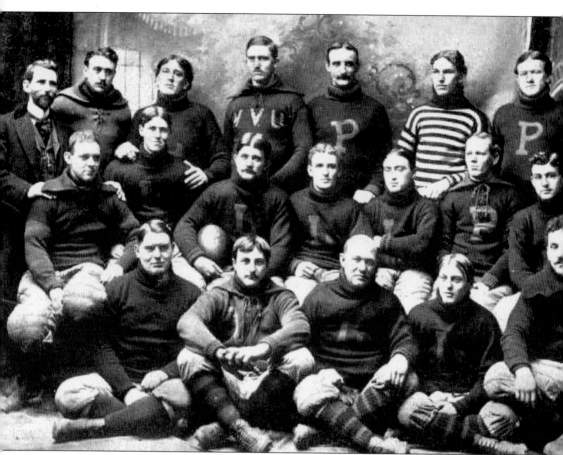

After being on top of the world in 1897, the men of Latrobe fell back a little the following season, losing their final three games after a 7-0 start. One of the main problems was that they were without their star quarterback, John Brallier, for most of the season. Brallier signed with Latrobe early on but left to join the PAC after three games, due to a more lucrative contract offer. Although he did come back to Latrobe when the PAC season was completed, it was too late. So frustrated were the team's faithful fans for their poor finish that they pelted the Greensburg entourage with everything they could find. Following a 6-0 defeat on a snowy day, which cost Latrobe the Westmoreland County Championship, one of the players was injured after being hit in the head by a rock. (Courtesy of the Latrobe Historical Society.)

1896.

Sept. 19.	Latrobe, 54—Imperials	6,	at Latrobe.
Oct. 3.	Latrobe, 12—Altoona	0,	at Latrobe.
Oct. 10.	Latrobe, 4—W. U. P.	0,	at Latrobe.
Oct. 24.	Latrobe, 38—Indiana	0,	at Latrobe.
Oct. 31.	Latrobe, 4—Greensburg	10,	at Latrobe.
Nov. 13.	Latrobe, 5—W. V. U.	0,	at Latrobe.
Nov. 14.	Latrobe, 0—W. V. U.	4,	at Latrobe.
Nov. 21.	Latrobe, 29—Indiana	0,	at Latrobe.
Nov. 26,	Latrobe, 0—Greenbsurg	10,	at Greensburg.
	Total, 136.	Total, 30.	

The 1896 Latrobe squad was a fabulous defensive team who allowed only 30 points in nine contests, shutting out five opponents. Unfortunately, their archrivals from Greensburg were too big an obstacle to overcome, defeating Latrobe both times they played. (Courtesy of the Latrobe Historical Society.)

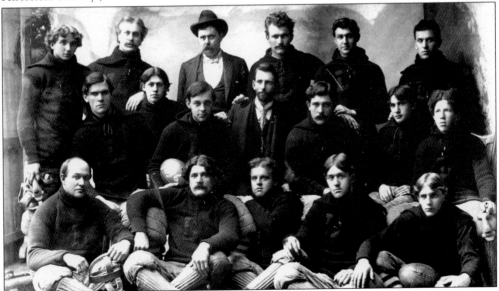

Star John Brallier returned to Latrobe from West Virginia University in 1896, following the third contest. Even though Brallier's return helped spark Latrobe to a 6-3 mark, the team was unable to defeat Greensburg, losing both games they played, including a 10-0 loss to close the season in front of 2,500 fans at Greensburg's Athletic Field. (Courtesy of the Latrobe Historical Society.)

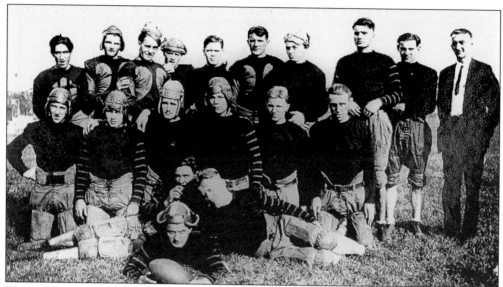

The Jeannette Athletic Association (JAA) played Latrobe on September 3, 1895, facing quarterback John Brallier. Latrobe won 12-0. (Courtesy of the Jeannette Historical Society.)

Before the first game the Latrobe club football team ever played, in 1895 against Jeannette, the Latrobe Cornet Band headed by Billy Showalter led both clubs into the field of battle with a parade down the streets of the Westmoreland County city. The hometown emerged victorious in the inaugural contest 12-0. (Courtesy of the Jeannette Historical Society.)

1897.

				
Sept. 25.	Latrobe,	28—Jeannette,	0,	at Latrobe.
Oct. 2.	Latrobe,	58—Emeralds	0,	at Latrobe,
Oct. 9.	Latrobe,	0 – Altoona,	0,	at Latrobe.
Oct. 13.	Latrobe,	22—Pgh. College	0,	at Latrobe.
Oct. 16.	Latrobe,	36—Altoona	0,	at Latrobe,
Oct. 23.	Latrobe,	14—Youngstown	4,	at Latrobe.
Oct. 27.	Latrobe,	30—W. U. P.	0,	at Latrobe.
Oct. 30.	Latrobe,	6—D. C. & A. C.	12,	at Allegheny.
Nov. 6,	Latrobe,	47—P. A. C.	0,	at Latrobe.
Nov. 13.	Latrobe,	19—Youngstown	0,	at Latrobe.
Nov. 20.	Latrobe,	12—Greensburg	6,	at Greensburg.
Nov. 25.	Latrobe,	16—W. V. U.	0,	at Latrobe.
Nov. 27.	Latrobe,	0—Greensburg	6,	at Latrobe.
	Total,	288. Total,	28.	

One of the most powerful squads in the land, Latrobe finished the 1897 season with a 10-2-1 mark, outscoring its opponents 288-28, while rendering nine opponents scoreless. Unfortunately, as in 1896, Latrobe ended the season on a bad note, succumbing to their rivals from Greensburg 6-0. Latrobe's Ed Abbaticchio fumbled a punt late in the first half, setting up the only score of the day. (Courtesy of the Latrobe Historical Society.)

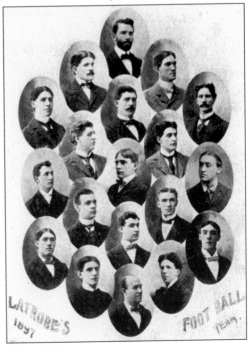

By 1897, Latrobe had matured into one of the best teams in the area. Many star players now dotted the Latrobe roster, such as John Brallier, Walter Okeson, and Harry Ryan, leading the Orange and Maroon to a fine 10-2-1 record. (Courtesy of the Latrobe Historical Society.)

41

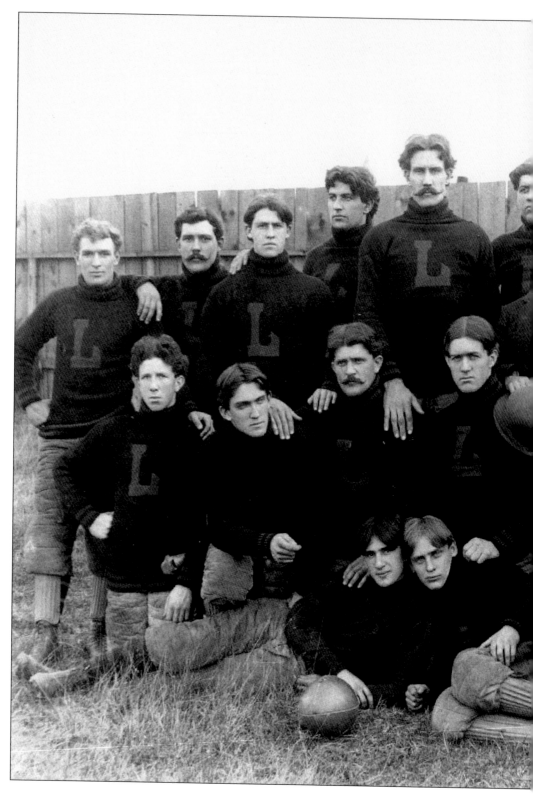

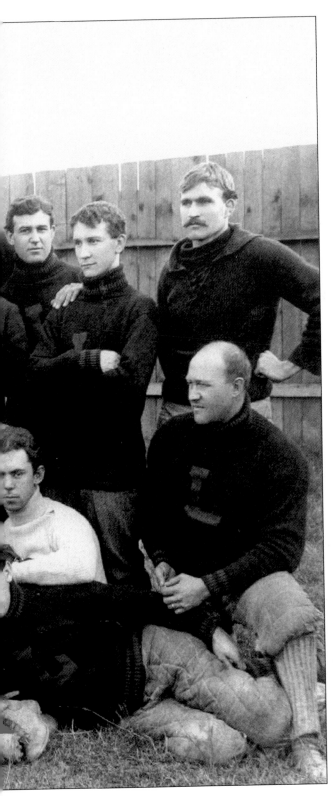

While Latrobe and Greensburg often fought savage battles on the field, years later they would have a fight of a different kind. Each team claimed that in 1897 they fielded the first all-professional team for an entire season. Historians question Greensburg's claim that they had 27 men on their roster in 1897 (a very high amount for the time) and that every man had been paid. Historian Robert Van Atta firmly claims that the Latrobe team (pictured here) "went all-professional in 1897, signing a number of college players from the east coast and as far west as Iowa." Regardless of the dispute, both clubs had magnificent seasons. They were two of the most powerful teams in the area and split their two games against each other; Greensburg took the first contest 12-6 before losing the season finale 6-0. (Courtesy of the Latrobe Historical Society.)

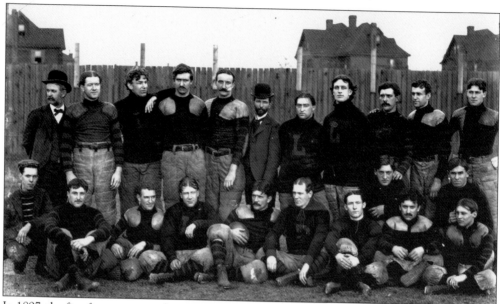

In 1897, the first free-agent wars began as city clubs aggressively enticed players to their local teams. During this season, both Greensburg and Latrobe set out to bring star George "Doggie" Trenchard to their respective squads. Latrobe eventually purchased his services for $75 a game. Even with Trenchard, Latrobe only split the two-game series, losing the last game of the season 6-0 as Greensburg won the Westmoreland County title. (Courtesy of the Latrobe Historical Society.)

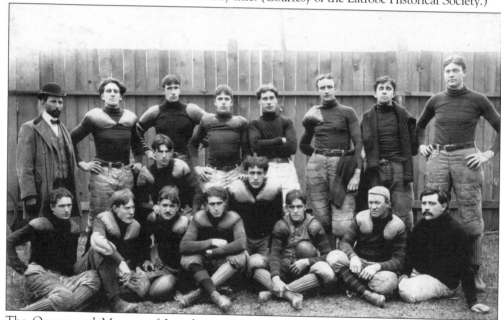

The Orange and Maroon of Latrobe served as the nucleus of an all-star team in a game contrived by manager David Berry. The idea was to put a team together with the best players from the area to face the Duquesne Country and Athletic Club on December 3 at Exposition Park, on the north shore of Pittsburgh. Edward "Eddie" Wood, Doggie Trenchard, Harry Ryan, George Krebbs, Bill Hammer, John "Jack" Gass, and Greenwood "Greenie" Lewis were on the all-star squad that lost to Duquesne 16-0. (Courtesy of the Latrobe Historical Society.)

1898.

Oct. 1.	Latrobe, 51—Jeannette,	0,	at Latrobe.
Oct. 8.	Latrobe, 18—McKees Rocks	0,	at Latrobe,
Oct. 12.	Latrobe, 17—Pgh. College	0,	at Pittsburg.
Oct. 15.	Latrobe, 50—Cottage Club	0,	at Latrobe.
Oct. 22.	Latrobe, 6—Greensburg	0,	at Greensburg.
Nov. 5.	Latrobe, 6—Greensburg	5,	at Latrobe.
Nov. 8.	Latrobe, 22—Pgh. College	6,	at Latrobe.
Nov. 19.	Latrobe, 0—D. C. & A. C.	17,	at Allegheny.
Nov. 24.	Latrobe, 0—P. A. C.	6,	at Pittsburg.
Nov. 30.	Latrobe, 0—Greensburg	6,	at Latrobe.
Dec. 3.	(All Stars) 0—D. C. & A. C.	16,	at Allegheny.
	Total, 170.	Total, 50.	

Coming off a solid 10-2-1 mark in 1897, coach A. E. Bull led his Latrobe club to a 7-3 record the following season. Despite shutting out their first five opponents (outscoring their first seven 174-11), Latrobe lost their last three games of the campaign. (Courtesy of the Latrobe Historical Society.)

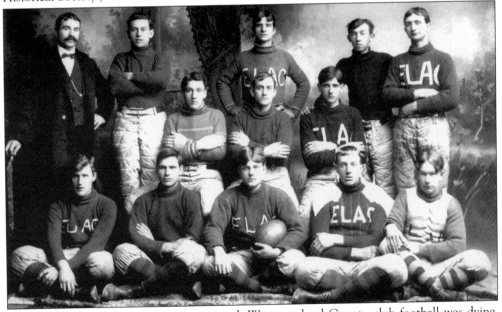

By the time the 20th century came around, Westmoreland County club football was dying. Only 1,000 patrons showed up for an 11-0 Latrobe victory against Greensburg, causing manager David Berry to cancel the scheduled rematch for a more lucrative contest against the Pittsburgh Athletic Club. (Courtesy of the Latrobe Historical Society.)

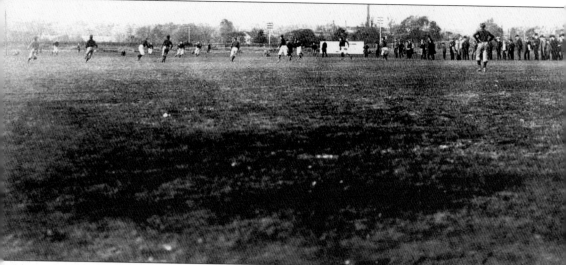

A player runs around the end trying to score a touchdown in a game during the late 1800s. Pudge Heffelfinger, a former All-American from Yale and the first professional football player (paid $500 by the Allegheny Athletic Association in 1892), helped make the end run an effective weapon. While at Yale, he became the first guard to perfect the pulling technique, a move in which an offensive lineman, instead of blocking straight ahead, pulls off the line, runs parallel to it, and then shoots forward to block, clearing a path for an end run. That technique became a mainstay of the some of the great professional running teams in history and reached its zenith in the 1960s with Vince Lombardi's Green Bay Packers. (Courtesy of the Latrobe Historical Society.)

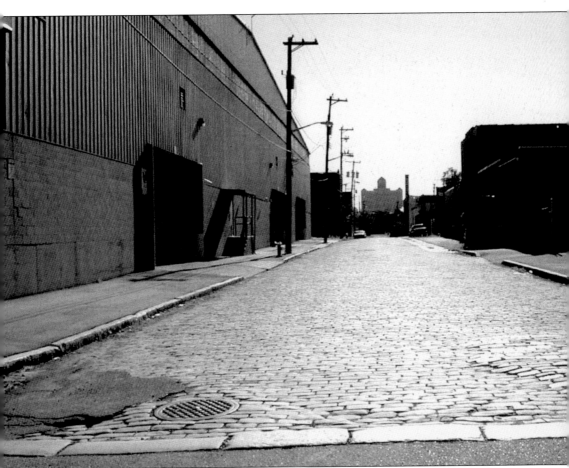

This group of warehouses off North and Galveston Avenues in Pittsburgh's North Side marks where Recreation Park used to stand in the late 1800s and early 1900s. Recreation Park was the home to the first professional football game ever between the Allegheny Athletic Association and the rival Pittsburgh Athletic Club. Recreation Park also served as the home of the Pittsburgh Pirates during the early days of the franchise's history.

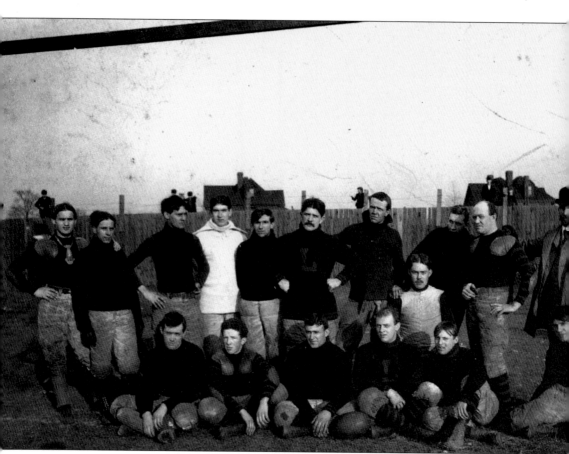

By the end of the 19th century, Dave Berry (the last man in the back row) had built Latrobe into not only one of the most powerful teams in Westmoreland County but in all of western Pennsylvania. Berry was an aggressive promoter and an innovator who not only invented the all-star game concept in 1898 but also helped form one of the first organized football leagues in 1902 with teams in Philadelphia and Pittsburgh. (Courtesy of the Latrobe Historical Society.)

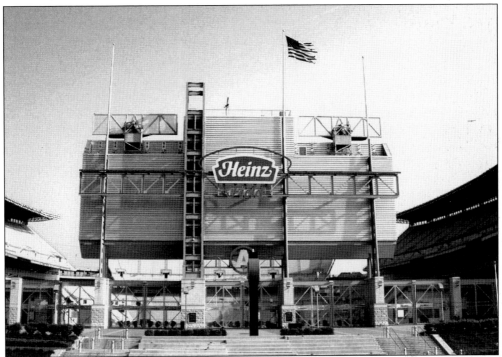

Where Exposition Park used to stand, the home of the Allegheny Athletic Association and the Duquesne Country and Athletic Club, also stood both Heinz Field (above) and Three Rivers Stadium (seen below just before its implosion). At the end of the 19th century, football players knew how much their efforts meant to their respective towns, but no one could have imagined how big the sport would become, not only in the Steel City but in the nation as a whole. Both sites have played a prominent role in developing the city's current professional team, the Steelers.

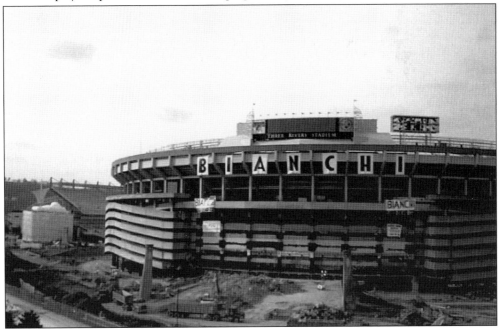

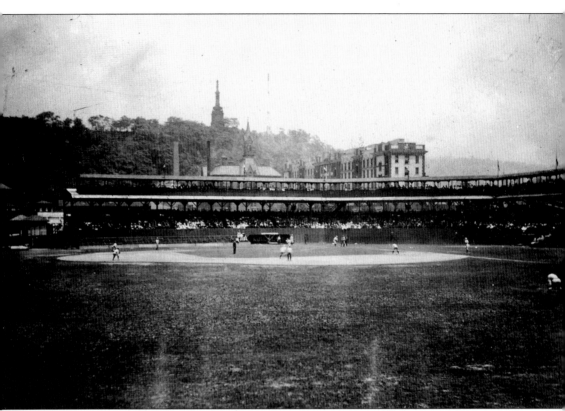

The Pittsburgh Pirates Exposition Park, on the shores of the Allegheny River, was home to some of the greatest club football contests of the late 1800s. The park held anywhere from 10,000 to 20,000 spectators. Because it was built up against the river, it would often flood. The flooding became such an irritant that the Pirates owner at the time, Barney Dreyfuss, decided to build a new stadium, Forbes Field, in the Oakland end of the city, far away from the rivers. Exposition Park is also famous for hosting the first World Series in 1903. (Courtesy of the Carnegie Museum.)

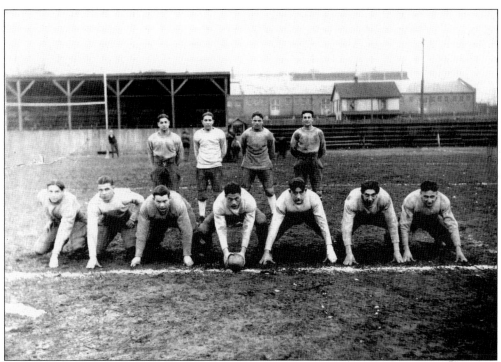

The Jeannette football teams of the 1890s played their games at West Jeannette Field. The field hosted not only the city's club and high school football teams but also semiprofessional baseball teams of the early 20th century. (Courtesy of the Jeannette Historical Society.)

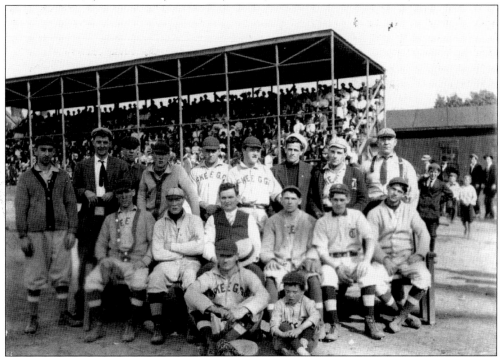

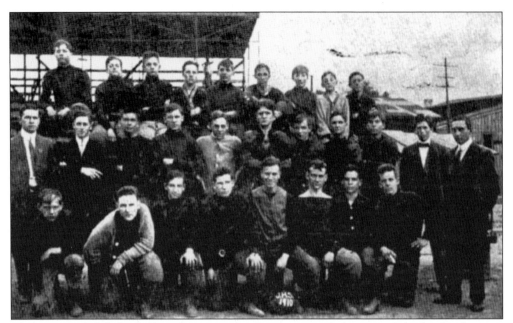

The success of club football in the area spurred an interest in the region's high school teams. Today, Friday evenings during football season in southwestern Pennsylvania mean high school football, and most football fans in the area spend their evening rooting for their respective city's school. Shown are the Jeannette High School teams of 1909 (above) and 1911 (below). (Courtesy of the Jeannette Historical Society.)

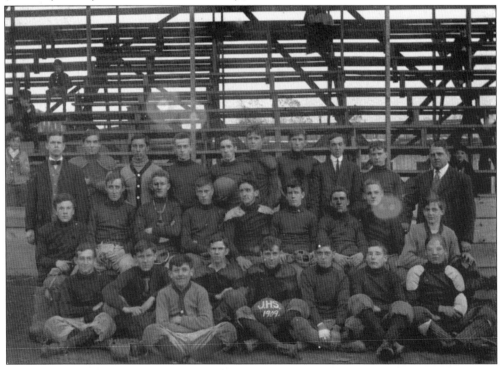

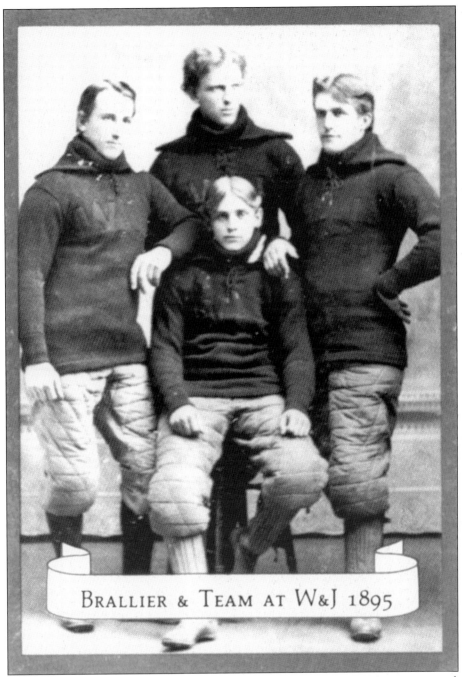

BRALLIER & TEAM AT W&J 1895

It was important for players in the late 1890s to keep their amateur status, as many went back and forth between college and club football. Shown with teammates in 1895 is John Brallier, who played for West Virginia University and Washington and Jefferson College. Collegiate squads were on the schedule to play many club teams during the season. Washington and Jefferson College seemed to be one of the most popular teams to appear. In 1895, the school went up against the perennial powerhouse, the Pittsburgh Athletic Club, losing at PAC Park 14-0. (Courtesy of the Latrobe Historical Society.)

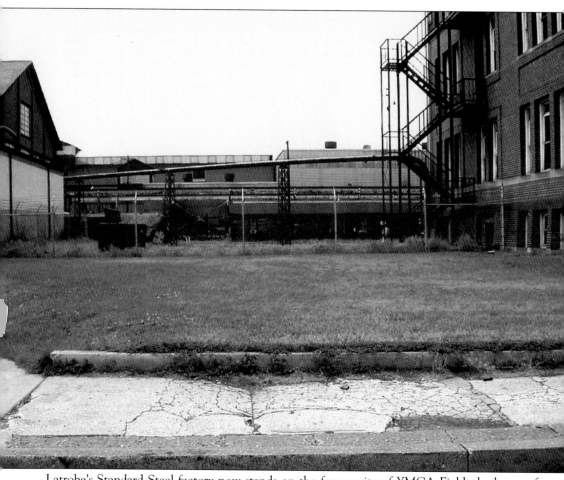

Latrobe's Standard Steel factory now stands on the former site of YMCA Field, the home of the Latrobe football club during the late 19th and early 20th centuries. YMCA Field was home not only to the famous $10 and cakes (expenses) game against Jeannette in 1895, during which quarterback John Brallier became what was thought to be the first professional football player, but it was also the home of the first all-professional football team in 1897. The steel company stands 300 yards southeast of the planned location of the football hall of fame in the 1950s and Memorial Stadium, the current home of Latrobe High School.

Three

THE PLAYERS

There were no Terry Bradshaws. There were not 80,000 rabid fans filling huge stadiums or millions of others watching worldwide on television. Football in the 1890s was not like the game today, but it was equally as important to the communities the teams represented so proudly. Probably the two biggest differences were the scoring (touchdowns were worth four points and extra points were worth two) and the role that gambling played in the game. While in modern football gambling is probably the biggest evil the NFL fears, back then it was not only accepted, but it enhanced the game.

Gambling and scoring aside, perhaps the other major difference in the two eras were the players. The skill and athleticism of the modern game replaced the toughness and fortitude of those who played in the late 1800s without the protection of much padding. Today's high-powered offenses and complex defenses were instead two lines attacking each other at full force with the back searching desperately for a hole within that mangled mess. There may not have been 1,000-yard rushers or 4,000-yard passers, but there were many players of superstar status.

Perhaps one of the most noted players of the era was the man who began professional football: Pudge Heffelfinger. Much has been written about Heffelfinger and his place in the history of professional football. It is well documented that he received $500 in 1892 to play for the Allegheny Athletic Association (AAA) against their rival, the Pittsburgh Athletic Club (PAC), making him the first professional player, but Heffelfinger was more than just a note in the history of professional football. He was an All-American lineman at Yale and was credited, in an era when a lineman's blocking sequences were only straight ahead, of becoming the first lineman to pull (moving along the line to create new holes for runners). For his efforts at Yale, he was elected to the College Football Hall of Fame. Heffelfinger was also a player of note with Chicago before he came to Pittsburgh to etch his name in the history of the game.

Heffelfinger came to the AAA from Chicago with Ben Donnelly, also known as "Sport." Donnelly, a tight end from Princeton, was considered a bit of a dirty player. He would take cheap shots at opponents to get them to retaliate, which more times than not would cause the opponent to be kicked out of the game. Ironically, it was this technique that resulted in the deal for Heffelfinger, making him the first professional football player.

A squad from New York refused to play Chicago unless Donnelly was benched. When the referee agreed, Heffelfinger, Donnelly, and Knowton Ames quit the Chicago team in support of

Donelly. The AAA then recruited Heffelfinger and Donnelly, paying Sport $250 in a contest against Washington and Jefferson College on November 19, 1892, thus becoming the second paid professional.

While much has been said about the men of Latrobe in this book, there were many other players in the area who were stars of the game. One of the premier football-playing families in the area was the Fiscus family. Ross Fiscus played with Donnelly for the AAA, while his brother Lawson was a star for Latrobe's main rival, Greensburg. Like Donnelly, Lawson was a rough, aggressive player. He eventually became a local police chief and caused a stir in the 1940s when he claimed that he, in fact, was the first professional player and not Dr. John Brallier of Latrobe. People discounted Fiscus's claim at the time, instead recognizing Brallier as the first professional. Eventually, it was discovered that Lawson Fiscus was paid $20 to play in 1894, a year before Brallier.

Heffelfinger, Donnelly, and Fiscus were proven to have been professional football players before Brallier, who ultimately was not even the fourth professional player but the seventh, as Peter Wright, James Van Cleve, and Oliver Rafferty were also paid before him, all of whom played for the AAA in 1893.

Joining Fiscus in Greensburg was George Barclay, who was the only member of the team to make the *Pittsburgh Times* All-Western Pennsylvania Team. Barclay went on to play major-league baseball with the St. Louis Cardinals and coached Greensburg in 1897 and 1898.

The Duquesne Country and Athletic Club had Posey Rose, a quarterback who had his shoulder separated in 1897 and retired; Ed Young; and Charley Gelbert, who was a three-time All-American at the University of Pennsylvania. Clarence Lomax, a tight end from Cornell, was a fine player and also the coach of the Pittsburgh Athletic Club in 1894.

These athletes, who played for the clubs that dotted the small towns in southwestern Pennsylvania, were the key elements of the fledgling professional version of football that got its roots in this area more than 112 years ago.

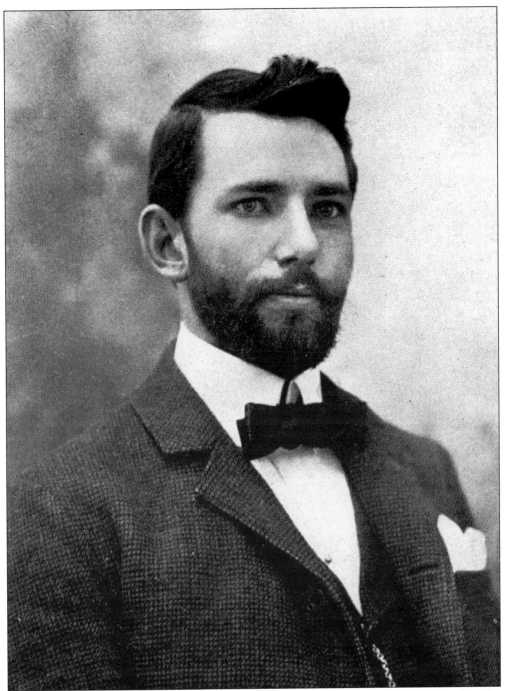

Other than John Brallier, Dave Berry was probably the most important figure in Latrobe football at the turn of the century. Berry was manager of the Latrobe squad during its great 1897 season. He arranged his lineup with rival Greensburg in mind. During an important defensive stand at the end of game with Greensburg, Berry rallied his troops, challenging them to "hold for the sake of dear old Latrobe!" Latrobe held Greensburg and won 6-0. (Courtesy of the Latrobe Historical Society.)

Shown here is John K. Brallier, star quarterback for the Orange and Maroon of Latrobe during the early days of professional football. Brallier, a 16-year-old quarterback from Indiana Normal School, was paid $10 and expenses by Dave Berry, manager of the Latrobe football team in 1895, because the club was desperate for a starting quarterback in the opening game against Jeannette. Because of this, years later Brallier was celebrated as the first professional football player. As it turned out, he was only the first one to admit he had been paid. (Courtesy of the Latrobe Historical Society.)

Brallier enrolled in Washington and Jefferson College in August 1895, shortly after his first game with Latrobe. Washington and Jefferson College had a strong football team at the turn of the century and played several good local clubs and Ivy League schools. Brallier played quarterback for the team whose only loss was to Pennsylvania Agricultural College, the forerunner to Penn State. They also defeated the Western University of Pennsylvania, the future University of Pittsburgh. (Courtesy of the Latrobe Historical Society.)

Brallier eventually transferred to West Virginia University (WVU), where he finished college. During those years, he continued to play for Latrobe on the side; the money allowed him to remain in college. He also brought a group of WVU players to Latrobe and played out the 1896 season for $150 and expenses. After the Spanish-American War, Brallier returned to the region and played for the Pittsburgh Athletic Club in 1898 before returning to Latrobe. (Courtesy of the Latrobe Historical Society.)

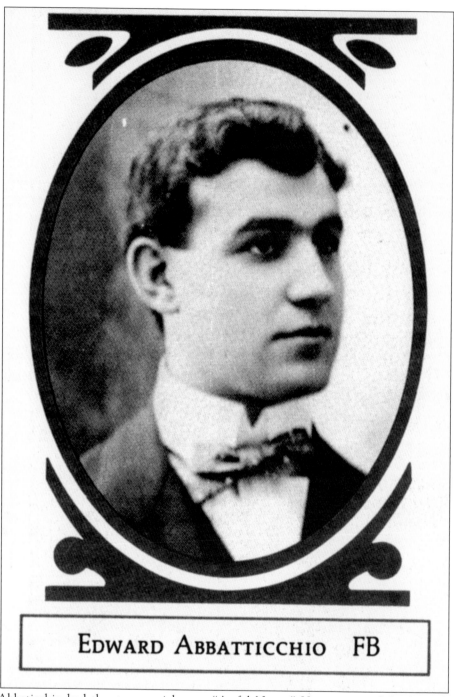

EDWARD ABBATTICCHIO FB

Ed Abbaticchio had the strange nickname "Awful Name." He was one of the best players Latrobe ever produced and was named to the All-Western Pennsylvania Team in 1897. "Batty," as he was also called, enjoyed a nine-year major-league baseball career, playing for the hometown Pirates between 1907 and 1910. He was an impressive sports pioneer who not only became the first Italian to compete in the majors but most likely the first on the gridiron too. (Courtesy of the Latrobe Historical Society.)

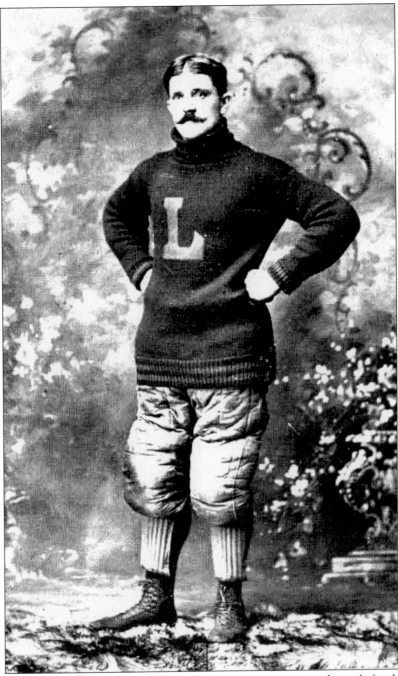

Harry Ryan was one of the most distinguished players ever to put on the pads for the Latrobe Athletic Club. Not only was he captain of the team, but he was also named to the All-Western Pennsylvania Team in 1897 by the *Pittsburgh Times*. Ryan had the distinction of playing in the first all-star game in 1898, when Latrobe manager Dave Berry led his team against the powerful Duquesne Country and Athletic Club. Ryan was a fixture on the team during the early 1900s, when he combined with Brallier to help the team become one of the most powerful squads in western Pennsylvania at the time. (Courtesy of the Latrobe Historical Society.)

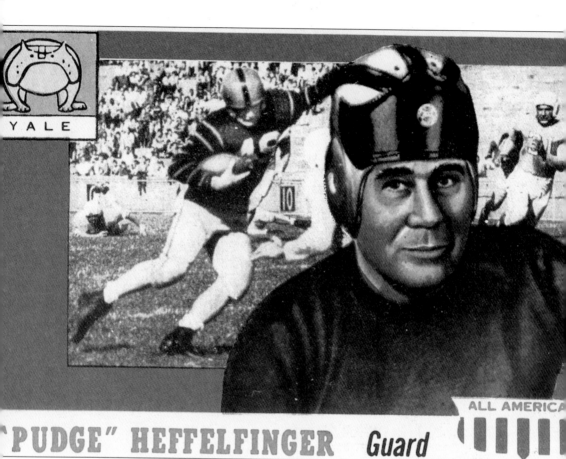

"PUDGE" HEFFELFINGER *Guard*

For over half a century, Brallier was considered to be the first professional football player ever, an honor that Heffelfinger probably would have wished he had kept. Heffelfinger went to his grave never admitting to being paid to play football in 1892. Heffelfinger was an All-American guard at Yale who, after a falling out with his team in Chicago, was coerced into playing with the Allegheny Athletic Association for $500. It was almost 70 years later when a researcher found the expense sheet proving that it was Heffelfinger and not John Brallier who was the first professional player. (Courtesy of the Topps Card Company.)

Sam and John Johnston were not only brothers but also two of the most important players on the strong Latrobe offensive line in 1897. They played in that glorious season that saw them defeat archrival Greensburg, only to lose to them two weeks later for the county championship. The Johnstons were standouts on the gridiron for the University of Iowa. (Courtesy of the Latrobe Historical Society.)

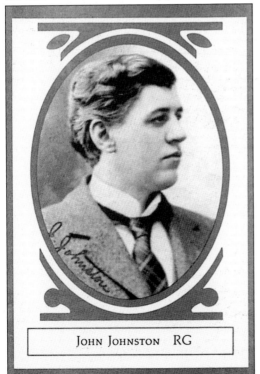

SAM JOHNSTON LG

JOHN JOHNSTON RG

One of the most interesting publications at Latrobe football manager Dave Berry's printing company, which also produced the *Latrobe Clipper*, was a book celebrating the Latrobe football teams of the late 19th century. The book, entitled *Football Souvenir: A History of Latrobe's Famous Team*, included the results of each season between 1895 and 1899, photographs of the great players, pictures of each team, and, of course, plenty of advertisements to make the publication more profitable. Berry, who ran the team through most of the 1890s and 1900s, was considered quite a promotional mastermind in his time. (Courtesy of the Latrobe Historical Society.)

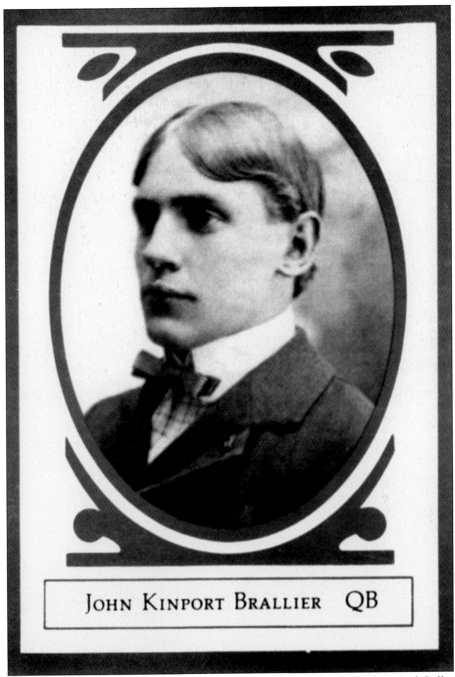

JOHN KINPORT BRALLIER QB

By 1899, Brallier left Latrobe football behind and was off to the Medico-Chiurgical College in Philadelphia to study dentistry. He played football there, too. Despite leaving, Brallier was never too far from his original roots both in the college game and in the professional game. Dr. Brallier returned to Indiana Normal School to coach, where he had played with the great actor Jimmy Stewart's father before Berry found him in 1895. He later returned to Latrobe, where he coached and quarterbacked the club to an undefeated record of 29-0 between 1903 and 1905. (Courtesy of the Latrobe Historical Society.)

There were many talented players on the undefeated 1905 Latrobe squad, but one of the men who helped orchestrate the offense was quarterback Murray. He continued the tradition of fine Latrobe quarterbacks that began with John Brallier and was Brallier's backup in the 1905 season. (Courtesy of the Latrobe Historical Society.)

Mike O'Connors was a substitute on the Latrobe football team in 1905. O'Connors hailed from Washington and Jefferson College, the same school that Brallier attended. (Courtesy of the Latrobe Historical Society.)

66

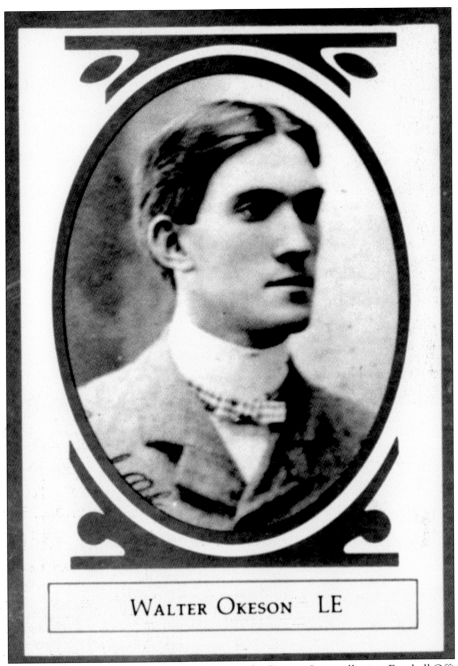

WALTER OKESON LE

Walter Okeson, from Lehigh, was a major figure in the Eastern Intercollegiate Football Officials organization and the NCAA Collegiate Rules Committee. He was hired not only as coach of the team but as one of its star ends. During his tenure in Latrobe, the *Pittsburgh Times* named Okeson to the All-Western Pennsylvania Team in 1897. During the campaign in 1897, when Latrobe fielded the first all-professional team in history, Okeson made perhaps the most important play of the season. He picked up a fumbled Greensburg punt and raced into the end zone, giving the Orange and Maroon a dramatic 12-6 victory. (Courtesy of the Latrobe Historical Society.)

Marcus Saxman played tight end and halfback for Latrobe. He was a fan favorite and known as a fearless and energetic player on both sides of the ball. As a halfback, he was known for attacking the line quickly; as a defender, he was known for open-field tackling. When comparing him to running backs in the modern era of the NFL, the two names that come to mind the quickest are Earl Campbell and Jerome Bettis, two battering rams who combined speed with incredible strength to make life very painful for opposing defensive players, a description that certainly seemed to fit Saxman's style of running. (Courtesy of the Latrobe Historical Society.)

The two unidentified players shown in these images played for the Jeannette football teams in the 1890s. While Jeannette played an important role in the early history of the professional game in 1895, facing off against Latrobe in the famous $10 and cakes game on Labor Day, they were generally one of the weakest teams in western Pennsylvania. Jeannette lost eight of nine games against Latrobe and Greensburg. Tying only Greensburg in a 0-0 forfeit in 1894, Jeannette never scored a point in the other eight contests; they were outscored 331-0. (Courtesy of the Jeannette Historical Society.)

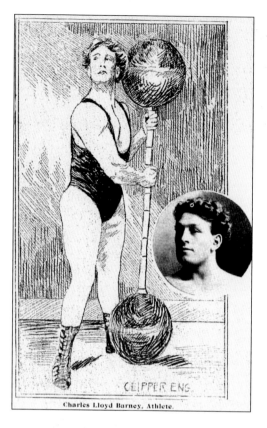

Charles Lloyd Barney, Athlete.

One of the members of the 1898 Latrobe squad was Charles Lloyd Barney. Barney, who played at Ohio Wesleyan University, was a famous strongman who performed various feats of strength at local fairs and expositions, including breaking chains and lifting horses. (Courtesy of the Latrobe Historical Society.)

Following stints on the offensive line as a center with the Philadelphia Athletics in 1902 and the classic Franklin team a year later, Lynn "Pop" Sweet played for the undefeated Latrobe club in 1905. (Courtesy of the Latrobe Historical Society.)

After receiving his stipend, Brallier was called on to defeat nearby Jeannette in the first game of the 1895 campaign, which also happened to be the first game the team ever played. Proving to be well worth the price, he took the team down the field for two scores and kicking a point after touchdown in the 12-0 shutout of Jeannette. After his exciting debut, Brallier spent his $10 football salary to buy pants to take with him to Washington and Jefferson College, where he was soon to attend. (Courtesy of the Latrobe Historical Society.)

While Marcus Wilson Saxman Jr.'s football career was short, he and his family's influence on Latrobe was huge. Saxman finished his football career and education before following his father to Latrobe Steel, the company his father founded in the 1800s. Saxman Jr. eventually became president of the company, a position he held until his retirement in 1960. Deeply involved in the community, he served on the Latrobe City Council and was president and a member of the board of the Latrobe Area Hospital. Saxman Jr. also served as a member of the board of the Latrobe Foundation charitable organization. The former Latrobe football great formed a company that purchased the land that eventually became the Latrobe Country Club. The company held the property until its sale to another Latrobe icon, Arnold Palmer. (Courtesy of the Latrobe Historical Society.)

Pictured here are the football pants of George Flickinger, a left tackle on the 1895 Latrobe club. Flickinger, one of the last surviving members of that historic team, was one of the toughest players to take the field. The pants were donated to the Latrobe Historical Society by his family and are currently on display there.

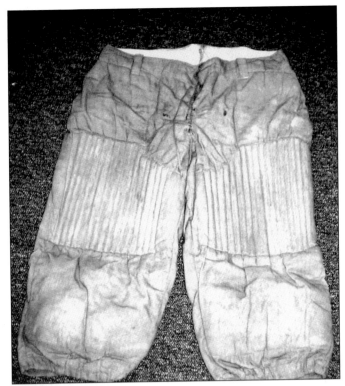

GEORGE FLICKINGER C/LT

Flickinger was not the biggest member of the Latrobe offensive line, standing only 5 feet 11 inches tall and 185 pounds as a center, but he was nonetheless a devastating blocker. He was known for being able to break up interference in the defensive backfield, allowing runners more room. (Courtesy of the Latrobe Historical Society.)

A. E. Bull played with Latrobe during their glory years. In 1898, when Brallier went into the army during the Spanish-American War, Bull played quarterback. During his tenure with the Orange and Maroon, Bull also coached the club, leading them to a strong 7-0 start before losing the last three games of the campaign, including the season finale to their archrivals from Greensburg 6-0. Bull, who was a tight end, also played at the University of Iowa and the University of Pennsylvania, where he was an All-American. He then went on to coach at his alma mater, the University of Iowa. (Courtesy of the Latrobe Historical Society.)

As far as timing goes, Dr. John Geiger's could not have been any worse. In the late 1890s, he seemed to be one year off from playing on some of the greatest teams of the time period. Geiger signed with the Duquesne Country and Athletic Club in 1897. Unfortunately for John, it was one season too soon. The club went 5-3 that campaign, one year before they became one of the best clubs of the decade with a 9-0-1 mark. The following season, the guard signed with Latrobe. Although his new club had a fine 7-3 mark, it followed a 10-2-1 campaign in 1897, a year when Latrobe made history by becoming the first all-professional team in history. (Courtesy of the Latrobe Historical Society.)

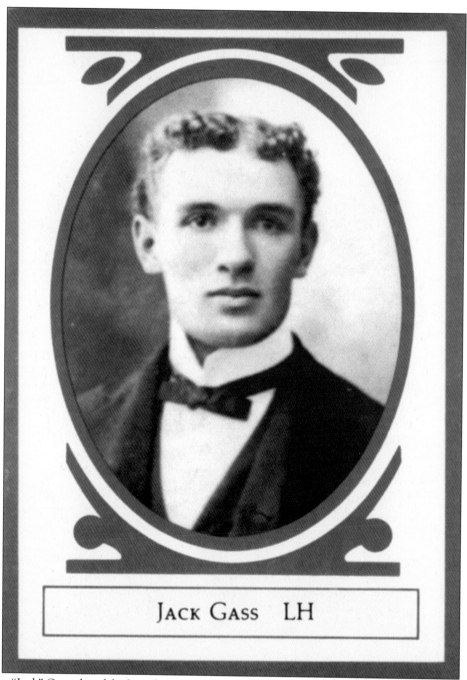

JACK GASS LH

John "Jack" Gass played for Latrobe in 1897, 1898, and 1900. In 1900, Gass left Latrobe to play for Greensburg, a move that is akin to a New York Yankee packing his bags to play in Boston. While with Latrobe, Gass was selected to an all-star team that went on to face the strongest club in the area during 1898, the Duquesne Country and Athletic Club. Throughout his career, which included a stop at Lehigh University, Gass was an exciting runner, who once scored on gallops of 60 yards and 90 yards in an 1897, 36-0 romp over Altoona. (Courtesy of the Latrobe Historical Society.)

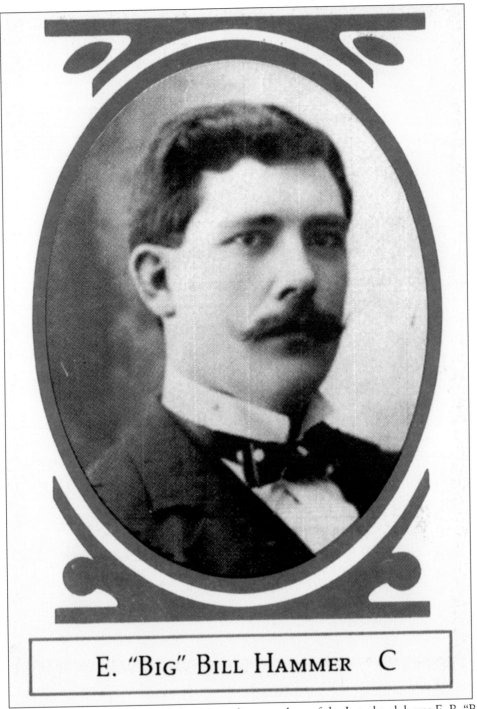

E. "Big" Bill Hammer C

At the turn of the century, one of the outstanding members of the Latrobe club was E. B. "Big Bill" Hammer. Hammer played center for the Latrobe squad in 1896, the same position he played at Indiana Normal School and Washington and Jefferson College. He was an outstanding blocker and was considered at the time to be the premier center in western Pennsylvania. (Courtesy of the Latrobe Historical Society.)

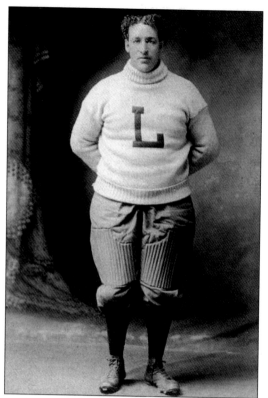

Edward Lang, a member of the 1898 Latrobe team, played an integral part in the club's dramatic 6-5 victory in a game against their archrivals from Greensburg. With Latrobe down 5-0 and Greensburg driving down deep into their territory late in the contest, Lang emerged from a pile of players with a fumble and ran 95 yards for the score. Later, future Pittsburgh Pirates player Ed Abbaticchio knocked a goal through, and Latrobe came away victorious. (Courtesy of the Latrobe Historical Society.)

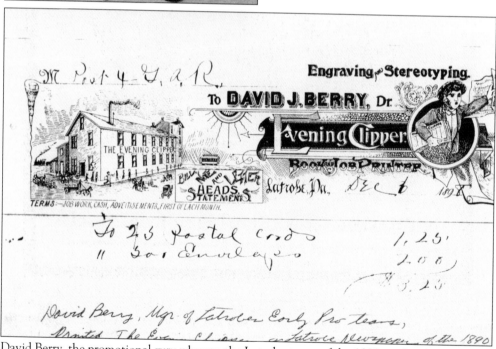

David Berry, the promotional guru who ran the Latrobe teams of the 1890s and early 1900s, was also editor of the *Latrobe Clipper*. Shown here is an invoice from the personal stationery of Berry for a printing job he performed in 1898. (Courtesy of the Latrobe Historical Society.)

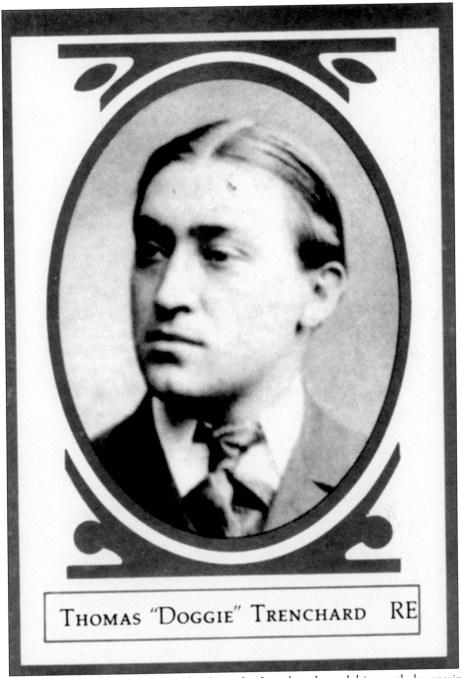

THOMAS "DOGGIE" TRENCHARD RE

George "Doggie" Trenchard, a clutch player for Latrobe, showed his worth by scoring a touchdown against Greensburg in an 1898 game after the Greensburg receiver mishandled a punted ball. Trenchard picked up the loose ball and trotted in for the touchdown. Latrobe won the game 6-0. Trenchard lived in New York City, where he played at Princeton before coaching at West Virginia University and the Western University of Pennsylvania. Many accused him of accepting money during his career, a claim he consistently denied. (Courtesy of the Latrobe Historical Society.)

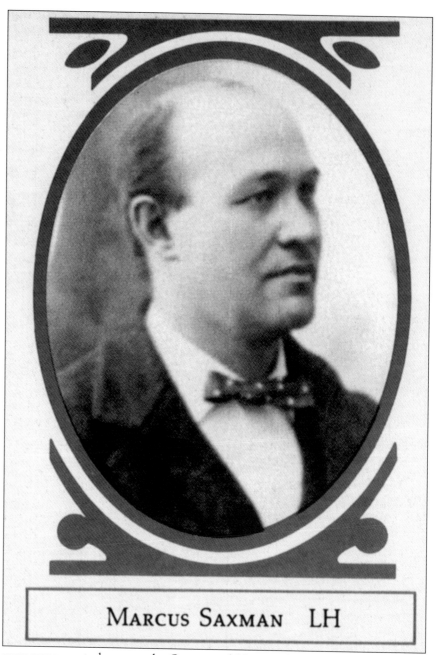

MARCUS SAXMAN LH

There were many great players on the Orange and Maroon clubs of Latrobe in the 1890s and early 1900s, but perhaps one of the best, if not the most athletic, was Marcus Saxman. Saxman played in Latrobe's first run of glory and was an outstanding all-around player no matter where he took the field: center, tackle, halfback, or fullback. He played some tremendous games for Latrobe, including one in 1897 against the Western University of Pennsylvania, where he scored two touchdowns. By 1899, the team was not of the caliber it had been a couple seasons earlier, and fewer fans were coming to the games; but Marcus, who was also an outstanding player at Swarthmore College, continued to play for Latrobe as an amateur. (Courtesy of the Latrobe Historical Society.)

Joe Donohue was a fixture of the local football scene at the turn of the century. Along with playing for Latrobe, he also played for Greensburg and kicked several clutch goals after for the team in 1897 and 1898, including one in Greensburg's 6-0 victory over Latrobe in 1897. Playing for Latrobe a few years later, Donohue started at right end for the phenomenal squad in 1905, helping the Orange and Maroon to a perfect 9-0 mark. (Courtesy of the Latrobe Historical Society.)

One of the staples on the offensive line for Latrobe during the first decade of the 20th century was starting center Joe Schisler. Schisler started for the club between 1903 and 1905, never losing a contest during that time. (Courtesy of the Latrobe Historical Society.)

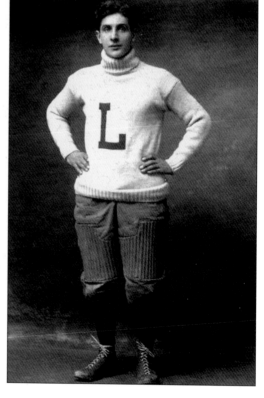

In 1905, Ben Lawson started at left halfback for Latrobe. Lawson was a solid player who contributed to the Orange and Maroon's undefeated campaign that included an impressive 10-0 victory against Philadelphia late in the season. (Courtesy of the Latrobe Historical Society.)

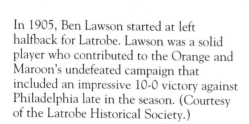

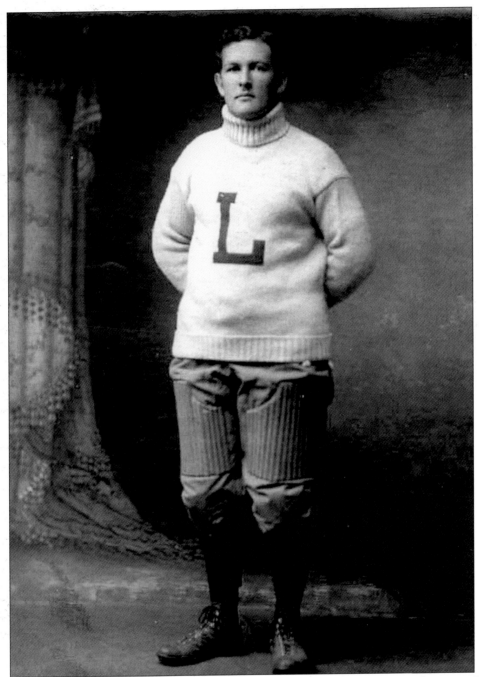

Charles Leo McDyre learned football while playing for Latrobe. While he was nowhere near the largest man on the club, he gave everything he had on every play. At 5 feet 10 inches tall and 165 pounds, he played left end and became a tremendous tackler, considered one of the speediest men on the Orange and Maroon. Because of his incredible attitude, McDyre became of the most popular players ever to step on the field for the Westmoreland County town. McDyre became a regular participant in the Latrobe squad's reunions through the years. (Courtesy of the Latrobe Historical Society.)

PLAYERS ON THE FAST LATROBE TEAM

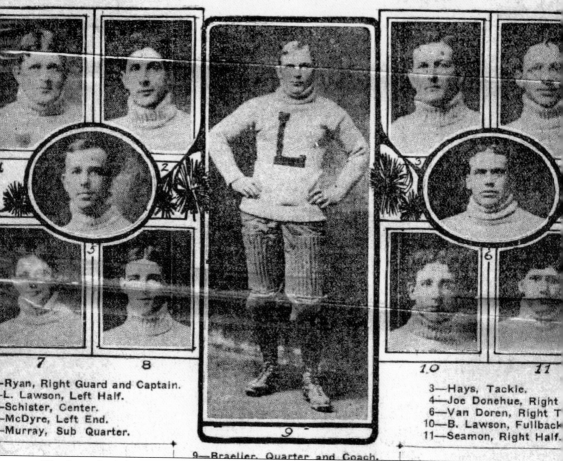

-Ryan, Right Guard and Captain.
-L. Lawson, Left Half.
-Schister, Center.
-McDyre, Left End.
-Murray, Sub Quarter.

3—Hays, Tackle.
4—Joe Donehue, Right
6—Van Doren, Right T
10—B. Lawson, Fullback
11—Seamon, Right Half.

9—Braelier. Quarter and Coach.

The legend of the powerful Latrobe team's of the early 1900s spread beyond Westmoreland County into Pittsburgh, as this paper on November 10, 1905, attests. Those great clubs from the scenic Pennsylvania town went undefeated between 1901 and 1905 and were much heralded for their speed. Listed on the front page were the starters for the Orange and Maroon, including the great Harry Ryan, who not only was the captain of the squad but had also been a staple in Latrobe since the first club in 1895. John Brallier also played for the team, doubling as the coach and quarterback. (Courtesy of the Latrobe Historical Society.)

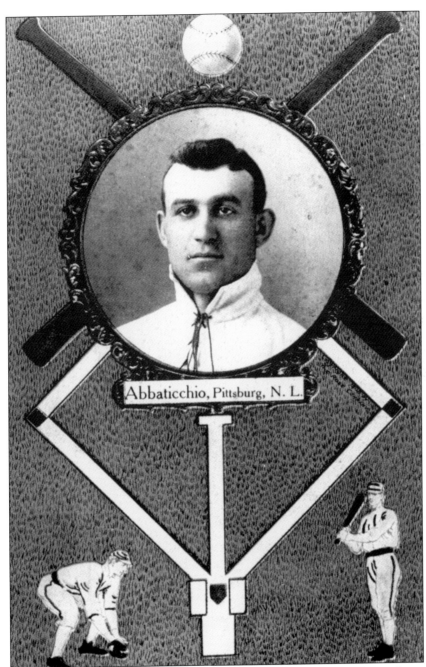

Abbaticchio, Pittsburg, N. L.

Ed Abbaticchio was more famous for being the first Italian player in major-league history than he was for being football player; but make no mistake, he was one of the finest ever to play on the classic Latrobe clubs at the turn of the century. Abbaticchio was a fullback who was very adept at busting through a defensive wall. He was also one of the finest punters at the time. Despite his successes on the gridiron, it was his prowess on the diamond that made Batty famous. Honus Wagner once stated, "Anyway you measured him, Ed was one of the best. As a player on the field he ranked with the top major league stars of his time." (Courtesy of the Latrobe Historical Society.)

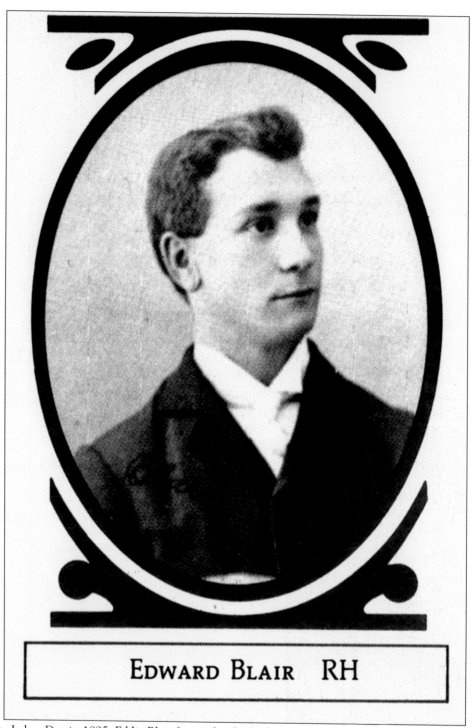

EDWARD BLAIR RH

On Labor Day in 1895, Eddie Blair forgot that he had a previous commitment to play baseball in nearby Greensburg, prompting Latrobe team manager Berry to replace him with Brallier. Before coming to Latrobe, Blair was a star at the University of Pennsylvania. (Courtesy of the Latrobe Historical Society.)

Dave Campbell was a big block of granite in Latrobe's 1895 line. He was six feet seven inches tall and 230 pounds, especially large for the era. Campbell scored two touchdowns in his career, returning fumbles against the Western University of Pennsylvania and against West Virginia University in 1897. (Courtesy of the Latrobe Historical Society.)

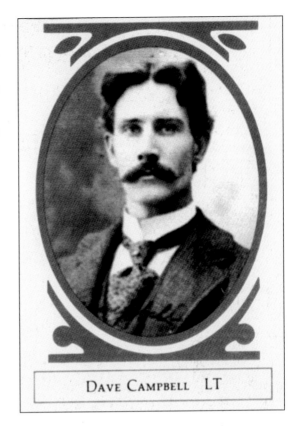

DAVE CAMPBELL LT

A halfback and fullback with the Orange and Maroon of Latrobe in 1903, Don Miller was a pivotal part of the club that not only went undefeated in nine games but also shut out every opponent. (Courtesy of the Latrobe Historical Society.)

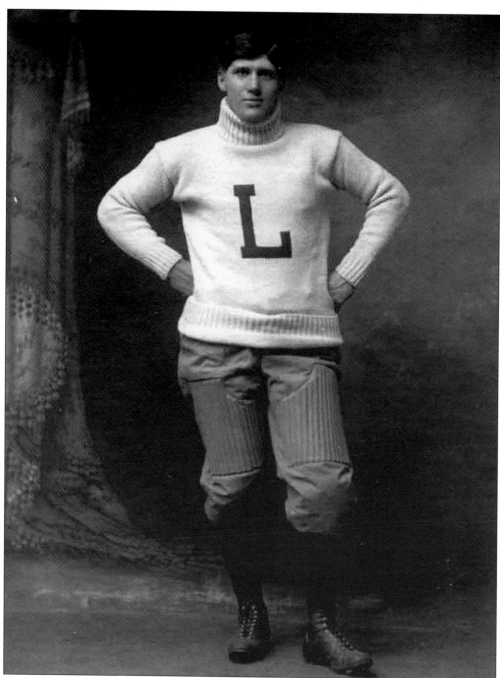

Seanor played left halfback in 1905 and was famous for a punt he made in the classic 6-0 victory against heavily favored Canton that year. With the game scoreless, Seanor kicked a punt over the head of Canton's returner Dave Cure. Rather than being tackled deep in his own territory, Cure tried to return the punt by kicking it, which was in the rules at the time. Harry Ryan blocked it, and Roy "Pop" Hayes picked it up and took it in for the winning score. The win proved to be one of the most dramatic and most important in the history of Latrobe professional football. (Courtesy of the Latrobe Historical Society.)

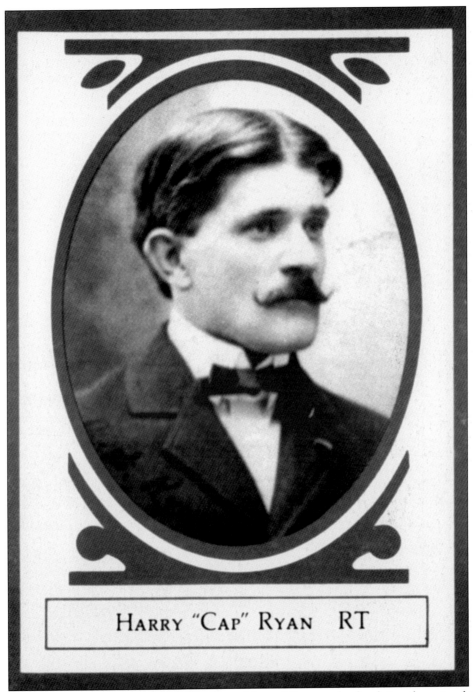

HARRY "CAP" RYAN RT

While great players may capture the attention of the public, great leaders bring championships to teams. Harry "Cap" Ryan was certainly the latter, one of the greatest leaders during the time period. Ryan was the undisputed leader of the Latrobe squad and stood by Brallier as a star of the team. The right tackle played for Latrobe, as well as West Virginia University, and was known as the player who knew the most about the game. Later, Ryan was named captain of the squad and, eventually, the team's coach. (Courtesy of the Latrobe Historical Society.)

Merle Blair, also known as "Molly," played many positions for the undefeated Latrobe YMCA club of 1903. Molly was a guard, tackle, and tight end for the team that went 9-0 in the campaign that season. (Courtesy of the Latrobe Historical Society.)

CHARLES McDYRE LE

Charles McDyre played on the 1897 Latrobe team that was considered the first all-professional squad ever assembled. McDyre was a top-notch defensive end and was said to be the greatest tackler ever to play on any team Latrobe fielded during the time period. (Courtesy of the Latrobe Historical Society.)

While William Doren was only a substitute for Latrobe in 1905, he was part of a club that was the best in western Pennsylvania during the first decade of the 20th century. Latrobe did not lose a game for four years between 1901 and 1905. (Courtesy of the Latrobe Historical Society.)

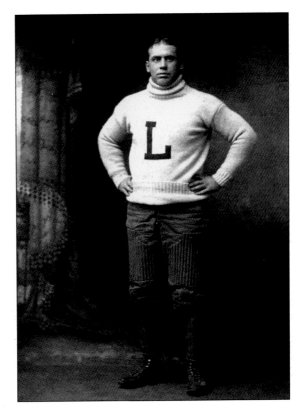

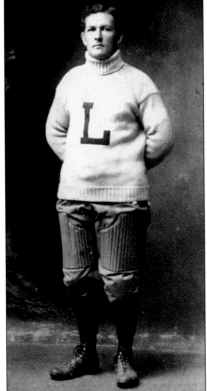

Roy "Pop" Hayes was a left guard with Latrobe in 1905 and was a star in perhaps the team's greatest victory in the early 1900s. Latrobe went 26-0 between 1903 and 1905, but the quality of their opponents was brought into question. In 1905, they played Canton, considered the toughest team there was at the time. With the game scoreless, Hayes picked up a blocked punt at the five-yard line and scored the only touchdown in a dramatic 6-0 upset. (Courtesy of the Latrobe Historical Society.)

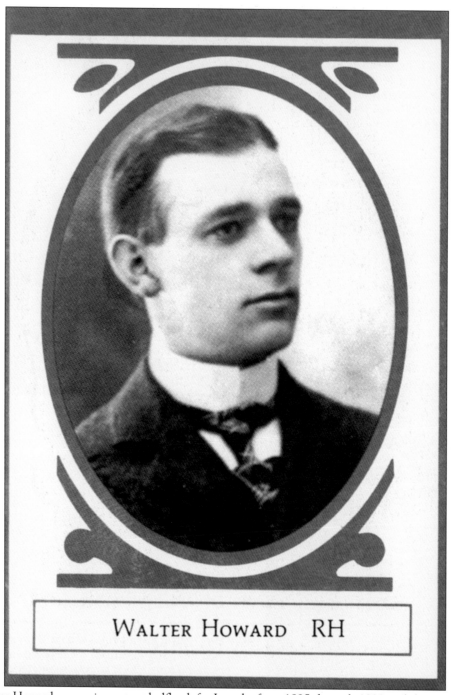

WALTER HOWARD RH

Walter Howard was an important halfback for Latrobe from 1895 through 1898 and then again in 1900. Besides his time with the Orange and Maroon, Howard also played for the Allegheny Athletic Association and participated in an all-star team in 1898 that opposed a powerful Duquesne Country and Athletic Club. Walter played college football at Cornell University and Lehigh University, where he also became a very fine punter and an effective running back. (Courtesy of the Latrobe Historical Society.)

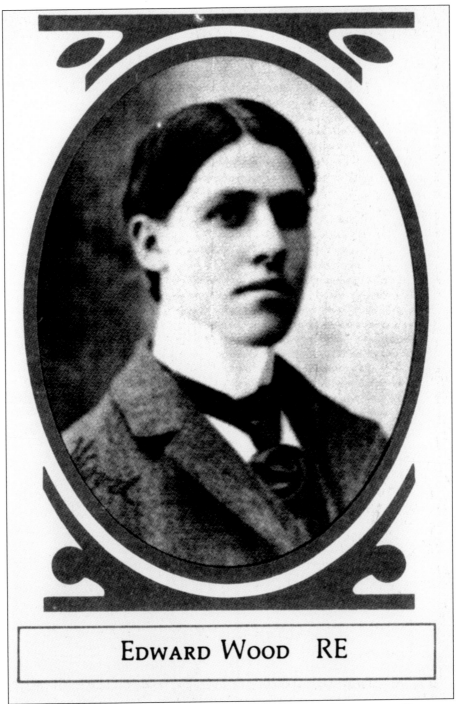

EDWARD WOOD RE

Edward Wood made the rounds in the football circles at the turn of the century. He was a tight end who played for Latrobe (from 1896 through 1898), Indiana Normal School, Washington and Jefferson College, and West Virginia University. Wood finished his career in Philadelphia and Franklin. He proved to be an outstanding presence at right end on defense and was selected to play on the 1898 all-star team. (Courtesy of the Latrobe Historical Society.)

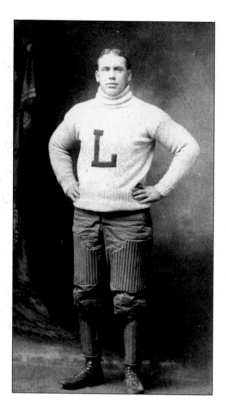

Van Dorn was a starting right tackle on one of the greatest clubs in Latrobe football history in 1905. Mounting a perfect 29 mark between 1903 and 1905, Latrobe outscored its opponents 794-5. (Courtesy of the Latrobe Historical Society.)

CHARLES SHUMAKER SUB

Despite the fact that he was only a substitute in 1895, Charles Shumaker has his name emblazoned forever on the plaque located outside Memorial Stadium in Latrobe celebrating that historical club. Shumaker had a great attitude and played anywhere he was needed. (Courtesy of the Latrobe Historical Society.)

94

Alex Laird was a lineman who played several positions on Latrobe's 1897 squad, which came close to defeating Greensburg for the county championship. Laird was a man with a tremendous attitude who gave everything he had on every play. (Courtesy of the Latrobe Historical Society.)

ALEX LAIRD SUB

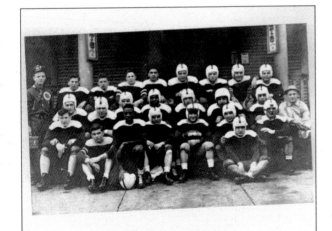

LATROBE ZIMBOS
1946-1950
...A Recollection

While the great professional football teams in Latrobe went by the wayside in the early 1900s, independent football reappeared in town in 1946, when the Latrobe Zimbos were formed. The Zimbos lasted only five years, going 15-9-5 before folding after four games in 1950. (Courtesy of the Latrobe Historical Society.)

95

There is no doubt that John Brallier became one of the best football players during the end of the 19th century and the beginning of the 20th century, but his life's work began in 1899, when he went across the state to Philadelphia to attend Medico-Chiurgical College and study dentistry. As he did with Latrobe, Indiana, Washington and Jefferson College, and West Virginia University, Brallier became a star for the college's football team. While he remained a force in Latrobe football in the first decade of the 20th century, Brallier also opened up a dental office in the Lowenstein Building in 1902. (Courtesy of the Latrobe Historical Society.)

Four

KEEPERS OF THE FLAME

Carl Mattioli and E. Kay Myers preserve the proud history of Latrobe. Mattioli, who is the president of the Latrobe Historical Society, and Myers, whose company produces the magazine *Around Latrobe*, have taken the legends of this scenic Westmoreland County city and fight tooth and nail to preserve their authenticity, even though some, at times, dispute their legitimacy.

While there is no questioning the fact that Latrobe is the home of the Rolling Rock Brewery, Fred Rodgers, and Arnold Palmer, there are other things that some have taken issue with, such as its claim to be the birthplace of the banana split. Wilmington, Ohio, a town 50 miles outside of Cincinnati, boasts that a man named Hazzard invented the ice-cream dish there in 1907. To their claim, Mattioli rebuffs it, simply stating, "We were the originators of the banana split," in reference to the story that Latrobe's Dr. David Stricker first came up with the culinary delight three years earlier, in 1904.

There is no quarrel with where the first professional football player in history played the game: Pittsburgh. For years, Latrobe was given the honor as the Birthplace of Professional Football because John Brallier was the first player ever to admit being paid to play the game. Admitting to being a professional football player at the turn of the century was considered unethical, and no one before Brallier would put their amateur status on the line by doing so, even after they finished their careers on the gridiron.

It was not until 70 years later, in the early 1960s, that Pudge Heffelfinger was proven to be the first professional player of all time. Nevertheless, for almost three decades up to that development, the NFL recognized Brallier and the city of Latrobe as the official Birthplace of Professional Football, even awarding it the bid to build the football mecca: the Professional Football Hall of Fame.

Latrobe's brush with being home to the Professional Football Hall of Fame began in 1945, not necessarily because it was perceived as the home of the first professional football player but almost as a pawn in the chess game for football supremacy between the National Football League (NFL) and the All American Football Conference (AAFC). The AAFC was an upstart league quickly establishing itself as a challenger to the more established NFL, spawning such impressive teams as the Cleveland Browns, San Francisco 49ers, and Baltimore Colts.

The NFL was looking for the upper hand and a place to build a sports museum to honor its greats like the National Baseball Hall of Fame and Museum in Cooperstown, New York, built a decade before. They decided to play the history card and awarded Latrobe the designation as the Birthplace of Professional Football while also presenting Brallier, who by this time had

become a successful dentist, a lifetime pass to attend any NFL game. Latrobe was also given the rights to build the hall of fame. In return, the quaint Westmoreland County town promised to recognize the NFL as the true and undisputed kings of professional football.

The marriage seemed like a perfect fit, except for one minor detail: the city would have to come up with the money to construct the building. NFL commissioner Bert Bell promised he would get the town some money to erect a facility that would include a stadium, but the NFL was not the cash cow that it is today. Any money the town would get they would have to raise by themselves.

A committee was put together that included Myers to raise the money to build the hall of fame. "We were members of the local Jaycees and it was a Jaycee project. At the time, the commission had an ulterior motive, to build a community center of which the Hall of Fame would be a part." Money was difficult to come by, and the project seemed to be stuck in neutral. Myers exclaimed, "Although we didn't receive any money from Latrobe Steel, we did get a letter from the company's president Marcus W. Saxman supporting the project. We went to Cleveland to get some funds from the league, and ended up at the Browns Stadium where we met with Paul Brown. He was very cordial, but he said 'You boys are too late,' as he had received a check for $200,000 from the Timken Ball Bearing Company to locate the building in Canton. Mr. Brown told us that if we could match that money 'We'd talk then,' but we couldn't match it."

Because of Latrobe's lack of finances, the NFL put the project up for grabs again, and the Timken donation was enough to secure the hall for Canton, Ohio. There was plenty of blame to go around, according to Myers. He said that while some felt Art Rooney could have pushed harder, others felt the blame might lie with the Latrobe Foundation. "Some members of the Latrobe Foundation thought it would make Latrobe too much of a tourist town and that it would upset the industrial base."

Regardless of the loss of the Professional Football Hall of Fame and the untold millions of dollars of revenue that went with it, Mattioli and Myers still keep the flame burning brightly, extolling the stories and the place Latrobe holds in the history of the game. After all, they still fielded the first all-professional team for an entire season in 1897 and played in the first all-professional game against their archrivals from Greensburg that season. The Latrobe Historical Society has vast resources and displays showcasing the team that was certainly among the best in the land. They still own the official designation from the NFL as the Birthplace of Professional Football, a title that is not only relevant because they are the home to the first all-professional football team but one that Mattioli and Myers still carry proudly for this city.

Here are John Brallier, George Flickinger, Harry Ryan, and Charles McDyre talking about their gridiron exploits for the Orange and Maroon of Latrobe at a meal in the mid-1940s. (Courtesy of the Latrobe Historical Society.)

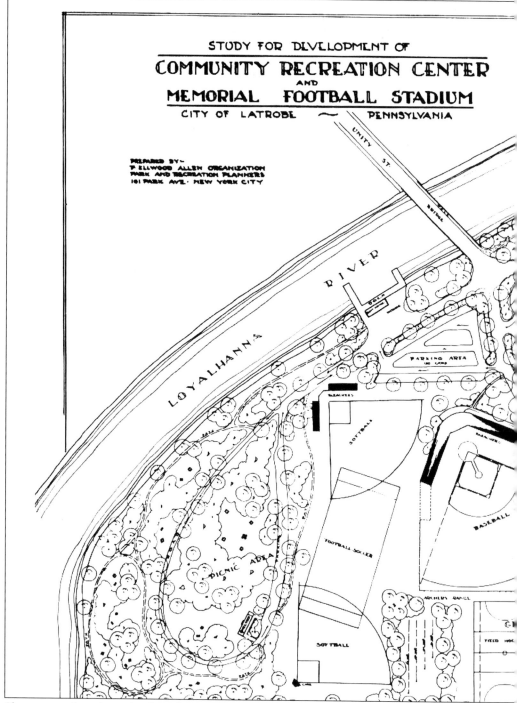

STUDY FOR DEVELOPMENT OF

COMMUNITY RECREATION CENTER
AND
MEMORIAL FOOTBALL STADIUM
CITY OF LATROBE ~ PENNSYLVANIA

Shown are the plans the Latrobe Football Committee had to build a hall of fame and community center for the citizens of the town. In 1947, a group of civic leaders decided that Latrobe should have a landmark celebrating their place as the Birthplace of Professional Football. Their conception included a massive community recreation facility, the focal point of

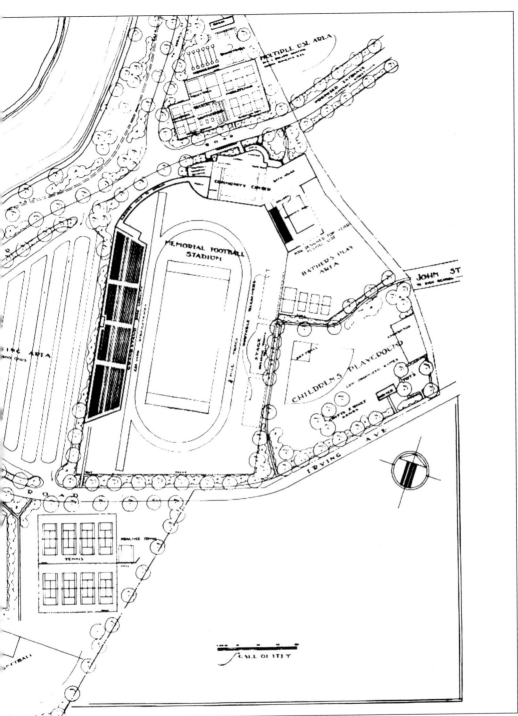

which would be a hall of fame for professional football. Besides a museum, the facilities included a football stadium, baseball field, and community center. The facility, as depicted above, exists almost in its entirety today, except for the hall of fame. (Courtesy of the Latrobe Historical Society.)

The surviving members of the classic turn-of-the-century Latrobe football teams gather together at Christmas to reminisce about the good old days. They were also on board to champion the cause of building the football hall of fame. Pictured above in the middle of the second row, from left to right, are George Flickinger, captain Harry Ryan, Dr. John Brallier, and Charles McDyre, all members of the 1895 squad. The four teammates recall their gridiron days below. (Courtesy of the Latrobe Historical Society.)

THE NATIONAL FOOTBALL LEAGUE

BOSTON, MASS.
BROOKLYN, N.Y.
CHICAGO (BEARS) ILL.
CHICAGO (CARDINALS)
CLEVELAND, OHIO
DETROIT, MICH.

GREEN BAY, WIS.
NEW YORK, N.Y.
PHILADELPHIA, PA.
PITTSBURGH, PA.
WASHINGTON, D. C.

310 SOUTH MICHIGAN AVENUE

CHICAGO 4, ILLINOIS

TELEPHONE
WABASH 3737

Oct. 25, 1944.

Dr. John Brailler
Latrobe, Pa.

Dear Doctor:

It has been months since we first started to get the Lifetime pass matter straightened out, but at every turn they kept reminding us there is a war on.

Now we finally have the passes in hand and yours is enclosed.

We thought it fitting that the first professional football player should have the first pass.

This will honored at all league games and does not have to be renewed each year, which makes it certain that you will not be without proper credentials when the first game rolls around next season.

Best wishes to you and with kindest personal regards, I remain,

Cordially,

George Strickler.

The NATIONAL FOOTBALL LEAGUE

LIFETIM

Extends to

No. 1

MR.

THE COURTESY OF ALL ITS PARKS FOR HONORABLE SERVICE
SUBJECT TO CONDITIONS ON BACK HEREOF

NON-TRANSFERABLE

This letter came from the offices of the NFL proclaiming John Brallier to be the first official professional football player. This honor and the city's designation by the NFL as the official Birthplace of Professional Football led Latrobe to originally securing the hall of fame. To honor Brallier for his accomplishments, the league issued him a lifetime pass to attend any NFL game he desired for the rest of his life. It was the first such pass that the NFL ever awarded to an individual. (Courtesy of the Latrobe Historical Society.)

This is the official logo, commissioned by the city leaders of Latrobe, commemorating the city and its claim as the Birthplace of Professional Football. (Courtesy of the Latrobe Historical Society.)

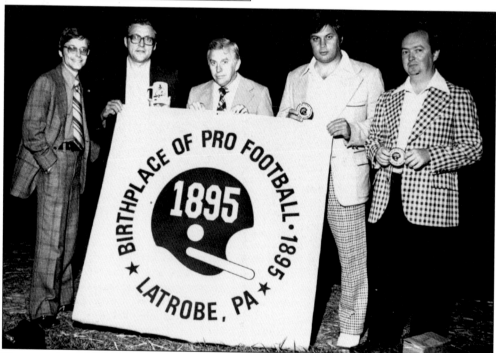

The unveiling of a new logo is shown proclaiming the city of Latrobe to be the Birthplace of Professional Football. From left to right are Tom Myers, Charles Boerio, Greg Garrison, and two unidentified men. (Courtesy of the Latrobe Historical Society.)

This flag symbolizes the things for which Latrobe is most proud. Along with its status in the history of professional football, it also claims to be the birthplace of the banana split, golfing great Arnold Palmer, children's television friend Fred Rogers, and the Rolling Rock Brewery.

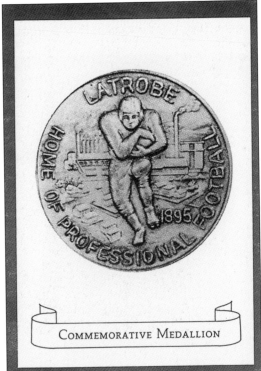

The origin and date of issue are unknown, but here is a medallion that was struck commemorating Latrobe's place in professional football history. Shown are the year Dr. John Brallier played in his famous $10 and cakes game and a steel mill, which represents one of the city's most important industries. (Courtesy of the Latrobe Historical Society.)

The Latrobe Historical Society is the keeper of the flame of Latrobe's 150-year history. The society, as part of its archives, also maintains several artifacts and documents on the city's football past. Pictured above is a football used by the historical teams of the late 19th century and early 20th century next to a photograph of the 1895 Latrobe football club. Below is a portrait of Latrobe's most famous gridiron star, Brallier.

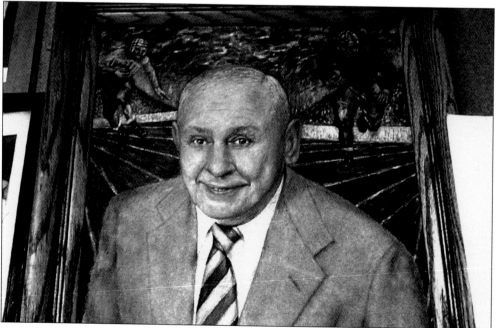

After the NFL declared Brallier the first professional football player in history, he became somewhat of a celebrity, as this envelope suggests. Brallier received many correspondences, such as the above the declaration, this one from a man who claimed to be the "World's Foremost Sports Collector." (Courtesy of the Latrobe Historical Society.)

To begin their quest to raise money to build the hall of fame, the Latrobe Football Committee put together this booklet that outlined their plans for fundraising. The plan was to be conveyed in a meeting with representatives of the NFL on July 19, 1947, in Pittsburgh. (Courtesy of the Latrobe Historical Society.)

Preparing a brochure for attractive visual presentation of the memorial to prospective donors. The booklet will be given a strong theme, such as: "Football is a $100,000,000 industry. Can you afford not to set aside at least 1% from your annual gross profit from this sport for its insurance and protection?"

Pledge cards and other fund raising aids will be printed.

A publicity kit will be prepared to assist in selling the idea locally throughout the country.

Football memorial dinners will be arranged for introduction of the idea in various sections of the country during the football season. These can tied effectively into the fund drive through invitation of prospective contributors and distribution of pledge cards and brochures.

At the same time, we will contact press, radio and motion picture people to publicize this activity.

Maximum assistance will be secured from the Governor, Legislature, Department of Commerce and other Pennsylvania organizations in promoting the idea nationally.

Fee.

We offer two alternate plans:

A flat fee of $1000 a month, plus expenses.

A monthly retainer of $500, plus expenses, against a fee of 4% of the sum raised.

Expenses.

Although it is difficult to estimate expenses in advance, it is advisable to budget for at least $10,000 a year, as follows: printing and postage, $2500; extra help, $5000; traveling and meeting expense, $2500.

It should be easy to obtain initial gifts to cover a year's operation of the

To fund the project, members of the Latrobe Football Committee had to convince the NFL, the Pennsylvania state government, and the local business leaders to contribute. Even back in the mid-1940s, civic leaders understood just how much of a financial impact professional football had in this country, and they would plead with members of the NFL, asking them to set aside 1 percent of their profits for the project. While the project got off to an aggressive start, eventually some of the city leaders did not understand the financial impact a hall of fame could have on the community. "Some members of the Latrobe Foundation thought it would make Latrobe too much of a tourist town and that it would upset the industrial base," committee member E. Kay Myers later admitted. (Courtesy of the Latrobe Historical Society.)

A LIVING MEMORIAL

... TO PROFESSIONAL FOOTBALL

...is in keeping with a national trend away from the ornate piles of granite, marble and bronze towards something vibrant, dynamic and useful. No higher tribute could be paid to the men who have brought professional football to its present high point of popularity and prestige.

IN LATROBE — ITS BIRTHPLACE...

... is the logical site for this memorial. Located on the main line of the Pennsylvania Railroad, bounded by the Lincoln and William Penn Highways, boasting a municipal airport, a stone's throw from metropolitan areas and the beauties of the Allegheny Foothills, a steel town in the heart of a steel country...it is a sports-minded community with a future. There's a ruggedness about steel-making which professional football has reflected since its birth in the shadow of the blast furnaces and open-hearths.

... OFFERS A CHALLENGE

TO —

The National Football League

and

The Community of Latrobe

IN THESE PROPOSALS...

A NATIONAL SHRINE ...

...in honor of the gridiron greats of yes year...a museum for the preservation o records and mementoes...a mecca for sp lovers of the nation where all can obt a panoramic view of a national institu tion on the actual site of the first p fessional game...to be the point of dominant interest in -

AN ATHLETIC PLANT

...which the shrine will overlook and to which it will be connected by an eleva archway...to include, of course, a spa cious football stadium, suitable for t staging of memorial games...and facili ties for other recreational activities which will assure its constant use... including -

A COMMUNITY CENTER...

...to adjoin the shrine itself...and to p vide facilities for persons of all groups and ages...to be the focal poin of all community leisure-time activity All of which will be situated in -

A RECREATION AREA...

...which for years has been in the process of development and into which thousands of dollars have already gone...already the scene of excellent recreation facilities...owned and operated by Latrobe groups ready to cooperate to t fulfillment of this project.

A proposal written by the Latrobe Football Committee shows what it hoped to accomplish with its fundraising drive. The facility included a museum that would, according to the proposal, "honor the gridiron greats of yesteryear," a proposed a new football stadium, a recreation facility that would include among other things several baseball fields, and a community center. The facility that they proposed was as much about participating in athletics as it was about honoring its history. The leaders hoped it would be something the whole city could utilize. (Courtesy of the Latrobe Historical Society.)

CHIEVEMENTS...
60 ACRE TRACT...
...of land is available for recreational developments and the professional football memorial. Expenditure for properties and improvement now totals $21,000.00

ATROBE RECREATION BOARD.
...is a legal body authorized under Pennsylvania state laws. Receipts during 1946 amounted to $28,419.55 with expenditures totaling $26,778.87 for a community recreation program. The state has alread: granted $5,500 for planning.

ATROBE BOROUGH COUNCIL...
...supports the program by appropriations of funds, labor and the use of equipment. Estimated expenditures during 1946 were $10,000.

ATROBE BOARD OF EDUCATION...
...cooperates by providing supervision of recreational activities and present a complete interscholastic athletic program. Current planning includes a new football stadium.

ATROBE FOUNDATION
...is a legal, non-profit association established to receive funds, grants and gifts to be used for recreational undertakings in Latrobe. $20,000 is now available for use.

OOTBALL MEMORIAL.
...Committee formed to promote a memorial to professional football.

— RESOLUTION —

WHEREAS, professional football in Ameri began in Latrobe, Pennsylvania, with a between Latrobe and Jeannette on Septem 3, 1895; and

WHEREAS, Dr. John K. Brallier of the La team was the first professional footbal player, and the National Football Leagu recognized as the authority on professi football in America

NOW, THEREFORE, BE IT RESOLVED, that th ional Football League officially recogn Latrobe, Pennsylvania, as the birthplac professional football in America.

AND BE IT FURTHER RESOLVED, that a comm consisting of three of our members be a ed to cooperate with and assist the Pro sional Football Memorial Committee of L Pennsylvania, in the selection and erect of a suitable memorial to the beginning professional football.

January 12, 1946.

By the end of the 1940s, the idea of placing a hall of fame in Latrobe had a full head of steam. Leaders of the project had laid out a plan of what it needed to complete the project. They thought they had received the blessing of the NFL. In 1946, the leaders of the NFL issued an official proclamation declaring Latrobe as the official Birthplace of Professional Football. It also had told the local government of its intentions to build the hall of fame there. (Courtesy of the Latrobe Historical Society.)

DELEGATES FROM LATROBE
MEETING WITH
NATIONAL FOOTBALL LEAGUE COMMITTEE

July 19, 1947 10:00 A. M.

PITTSBURGH STEELER OFFICE
UNION TRUST BLDG., PITTSBURGH, PENNA.

N. Funk.......Chairman, Latrobe Profes-
 sional Football Committee;
 President, Western Pennsyl-
 vania Interscholastic Ath-
 letic League; Principal,
 Latrobe High School.

as W. Saxman Jr. President, The Latrobe
 Foundation; President,
 Latrobe Electric Steel Co.

y S. Saxman....Chairman, Latrobe Recrea-
 tion Board; Secretary-
 treasurer, Latrobe Electric
 Steel Co.

d D. Bowman....Member, The Latrobe Found-
 ation, Vice-president,
 Vanadium Alloy Steel Co.

ge F. Brown....Vice-chairman, Latrobe
 Recreation Board; Member,
 Board of Education; Presi-
 dent, Pullman Mfg. Co.

iam S. McGuire.Member, Latrobe Borough
 Council; Member, Latrobe
 Recreation Board.

ld A. Stewart..Member, Board of Education;
 Attorney.

rt I. Snyder...Secretary, The Latrobe
 Foundation; Secretary,
 Latrobe Recreation Board;
 Director of Recreation.

lwood Allen....President, F. Elwood Allen
 Associates, Park and Recrea-
 tion Planning, New York.

LATROBE
SUPPORTING ORGANIZATIONS

Greater Latrobe Association

Recreation Board

Latrobe Foundation

B. P. O. E.

Kiwanis Club

American Legion

A. M. V. E. T. S.

Borough Council

Board of Education

Rotary Club

Lions Club

Veterans of Foreign Wars

Latrobe Ptg. & Publishing Co

The representatives of the city of Latrobe give charge for raising the finances to bring the football hall of fame to the city. The committee was headed by Mark Funk, who not only was the president of the Latrobe Football Committee but principal of Latrobe High School and president of the Western Pennsylvania Interscholastic Athletic League. Also shown are the various Latrobe businesses and organizations that supported the project. Lack of drive is blamed for the failure of the project to advance. (Courtesy of the Latrobe Historical Society.)

THE NATIONAL FOOTBALL LEAGUE

BOSTON, MASS.
BROOKLYN, N.Y.
CHICAGO (BEARS) ILL
CHICAGO (CARDINALS)
CLEVELAND, OHIO
DETROIT, MICH.

GREEN BAY, WIS.
NEW YORK, N.Y.
PHILADELPHIA, PA.
PITTSBURGH, PA.
WASHINGTON, D.C.

TELEPHONE
WABASH 3737

April 20, 1945

310 SOUTH MICHIGAN AVENUE
CHICAGO 4, ILLINOIS

Mr. Ray B. Johnston, President
Greater Latrobe Association
308 Main Street
Latrobe, Pa.

Dear Mr. Johnston:

 The National Football League, at its annual meeting in New York, felt that the idea of establishing Latrobe as the birthplace of professional football was a good one, but they did not feel that any action in regard to a Memorial should be taken at this time. It can be discussed more fully after the war is over, and a better idea of what should be, and can be done, would exist at that time.

 The efforts and the interest in professional football of the organization in Latrobe are sincerely appreciated. I will keep in touch with you.

 Yours sincerely,

Elmer F. Layden,
Commissioner

HTN

While a meeting with the NFL about the project was still a couple years away, NFL commissioner Elmer Layden—more famous for his exploits on the field as one of the four horseman for the Fighting Irish of Notre Dame—seemed supportive of the project, as stated in the letter below to Greater Latrobe Association president Ray B. Johnston. Layden became NFL commissioner in 1941, after an eight-year stint as head coach of his alma mater, following the death of Knute Rockne in 1933. He later went on to endorse the designation of Latrobe as the Birthplace of Professional Football but held off any plans for a hall of fame until after World War II ended. (Courtesy of the Latrobe Historical Society.)

THE NATIONAL FOOTBALL LEAGUE

BOSTON, MASS.
BROOKLYN, N.Y.
CHICAGO (BEARS) ILL
CHICAGO (CARDINALS)
CLEVELAND, OHIO
DETROIT, MICH.

GREEN BAY, WIS.
NEW YORK, N.Y.
PHILADELPHIA, PA.
PITTSBURGH, PA.
WASHINGTON, D.C.

TELEPHONE
WABASH 3737

March 29, 1945

310 SOUTH MICHIGAN AVENUE
CHICAGO 4, ILLINOIS

Mr. Ray B. Johnston, President
Greater Latrobe Association
308 Main Street
Latrobe, Pennsylvania

Dear Mr. Johnston:

I was glad to hear of the interest of the Greater Latrobe Association in having a suitable memorial for the birthplace of professional football.

Please let me know what plans were discussed, and what definite plans were decided upon. I endorse the idea personally, but would like to hear more about it, and will be glad to bring it before the members at our League meeting in New York City, which begins April 6th.

Give my warmest regards to Dr. Braillor.

 Yours sincerely,

Elmer F. Layden,
Commissioner

HTN

WRIGLEY FIELD, HOME OF THE BEARS

CHICAGO BEARS FOOTBALL CLUB
INCORPORATED

GEO. S. HALAS
President-Treasurer

J. W. McMILLEN
Vice-President

WALTER H. HALAS
Vice-President

R. D. BRIZZOLARA
Secretary

NATIONAL CHAMPIONS 1921-1932-1933-1940-1941-1943
WESTERN CHAMPIONS 1934-1937-1942

Telephone
FRAnklin 6040

37 SOUTH WABASH AVENUE
CHICAGO 3, ILLINOIS

December 27, 1946

Mr. M. N. Funk, Chairman
Latrobe Professional Football Memorial Committee
Latrobe, Pennsylvania

Dear Mr. Funk:

Thank you for your letter of December 21 in which
you indicated you would postpone the meeting of
your committee until January 28 or January 29 be-
cause of the change in the date of our meeting
here in Chicago.

I will discuss the possibility of stopping at
Latrobe, Pennsylvania with Bert Bell in order to
meet with you on one of those dates.

With best wishes, I am,

Sincerely yours,

President

GSH:mrl

While NFL giants George Halas of the Chicago Bears and George Marshall of the Washington Redskins seemed to be staunch supporters of a hall of fame in Latrobe, getting them together with the other league owners to discuss the plan seemed to be a huge challenge for Latrobe Football Committee chairman Mark Funk. Letters like these came often to Funk, first giving potential dates for a meeting then another canceling due to business. (Courtesy of the Latrobe Historical Society.)

EASTERN CHAMPIONS
1936, 1940, 1943, 1945

WORLD'S CHAMPIONS
1937, 1942

The Redskins

PRO-FOOTBALL, INC.
739-9TH STREET, N.W.
WASHINGTON, D.C.

REPRESENTING
THE NATION'S CAPITAL
IN
THE NATIONAL FOOTBALL LEAGUE

November 8, 1946

Mr. M. N. Funk, Chairman,
Latrobe Professional Football Memorial Comm.
Latrobe, Pennsylvania.

Dear Mr. Funk:

Replying to your letter of November 7th ---
I believe the probably best time would be the day following
our meeting in Chicago which is the 9th, 10th, and 11th of
January. At least it would fit in better with my plans.

Sincerely yours

George Preston Marshall

TELEPHONE:
GRant 2150

521 GRANT STREET
PITTSBURGH 19, PENNA.

November 7, 1946

Mr. M. N. Funk
Latrobe Professional Football
Memorial Committee
Latrobe, Pa.

Dear Mr. Funk:

Your letter addressed to Mr. Rooney was handed to me today for reply.

I will be very happy to contact you on or about December 15th. advising you of a suitable date for Mr. Rooney to attend this get together. As you know he is busy with other enterprises and it is impossible to make a date this far in advance, however I will be happy to inform you the date mentioned above.

Kindest personal regards.

Very truly yours,

J. D. Holahan
General Manager

LMU

Steelers owner Art Rooney proved to be one of the biggest supporters of building the facility in Latrobe. In 1961, when the NFL decided to bring the issue of a hall of fame to a vote after years of inactivity by Latrobe, Rooney was the only owner to vote for the Westmoreland County town; the others cast their vote for Canton, Ohio. (Courtesy of the Latrobe Historical Society.)

Judge Samuel Weiss (who also doubled as the commissioner of the Pennsylvania Professional Football League, a semiprofessional outfit) wrote Funk in 1947 to tell him of the confidence he had that the NFL would support the project financially. (Courtesy of the Latrobe Historical Society.)

Pennsylvania Professional Football League

WESTERN DIVISION
McKEES ROCKS, JOHNSTOWN, McKEESPORT
NEW KENSINGTON, ALTOONA, JEANNETTE

EASTERN DIVISION
SHAMOKIN, HARRISBURG, POTTSVILLE
SHENANDOAH, ALLENTOWN, YORK

OFFICE OF THE COMMISSIONER
JUDGE SAMUEL A. WEISS

703 CITY-COUNTY BUILDING
PITTSBURGH, PA.

PHONE ATLANTIC 4900, EXT. 214 OR 294
OR ATLANTIC 2772

October 15th
1 9 4 7

Mark Funk, Supt. of Schools
Latrobe, Pennsylvania

Dear Mark;-

Enclosed is letter from Bert Bell dated October 13,
1947, and I am sure the League are really going to
help you get started in your project at Latrobe.

When you are in Pittsburgh sometime, let me know,
and I will be glad to talk to you about this matter.

Sincerely yours,

saw:l

NATIONAL BASEBALL MUSEUM, INC.
Cooperstown, New York

President - Stephen C. Clark Vice-President - Rowan D. Spraker Treasurer - Paul S. Kerr
Secretary - Walter R. Littell Acting Curator - Janet R. MacFarlane

HALL OF FAME
and
NATIONAL MUSEUM OF BASEBALL

April 26, 1945

Mr. Ray B. Johnston, President
Greater Latrobe Association
308 Main Street
Latrobe, Pennsylvania

My dear Mr. Johnston:

Congratulations on the establishment of Latrobe as the birthplace
of professional football. I am certain that the shrine that you plan
will be worthy of the game.

Under separate cover I am sending you a booklet from the Hall of
Fame which gives the story of what we are and what we have accomplished.
I think that this will give you what you need.

Very sincerely yours,

Janet R. MacFarlane
Acting Director

JRM/oab

In an effort to help their brethren in football, Janet MacFarlane, acting director of the National Baseball Hall of Fame and Museum, sent a note not only congratulating Latrobe for its official declaration as the Birthplace of Professional Football but also offering support for the construction of a hall of fame. Baseball opened its hall six years earlier in Cooperstown, New York. (Courtesy of the Latrobe Historical Society.)

THE NATIONAL FOOTBALL LEAGUE

WEST
CHICAGO (BEARS) ILL.
CHICAGO (CARDINALS)
DETROIT, MICH.
GREEN BAY, WIS.
LOS ANGELES, CAL.

EAST
BOSTON, MASS.
NEW YORK, N.Y.
PHILADELPHIA, PA.
PITTSBURGH, PA.
WASHINGTON, D.C.

COMMISSIONER'S OFFICE
1518 WALNUT STREET
PHILADELPHIA 2, PENNA.
Telephone KIngsley 5-6650

September 30, 1947

Mr. Mark Funk
LATROBE PROFESSIONAL FOOTBALL MEMORIAL COMMITTEE
Latrobe, Pa.

Dear Mr. Funk:

I am in receipt of your letter of September 27th and I am delighted to hear that you are getting along so well with the memorial project.

I agree with you that we should wait until a later date to have our meeting and I shall be glad to meet with you at any time in the future that you may suggest.

Sincerely yours,

Bert Bell

Bert Bell, Commissioner

BB:aor

A key part of the plan was to seek financial assistance from the NFL. This letter, written in 1947 to Funk from the hall of fame commissioner of the NFL, Bert Bell, intends to set up a meeting between the league and the Latrobe Football Committee to see what support they could count on from the NFL. The hall of fame project committee members in Latrobe felt, at the time, they had support they needed from the league. (Courtesy of the Latrobe Historical Society.)

THE NATIONAL FOOTBALL LEAGUE

WEST
CHICAGO (BEARS) ILL.
CHICAGO (CARDINALS)
DETROIT, MICH.
GREEN BAY, WIS.
LOS ANGELES, CAL.

EAST
BOSTON, MASS.
NEW YORK, N.Y.
PHILADELPHIA, PA.
PITTSBURGH, PA.
WASHINGTON, D.C.

COMMISSIONER'S OFFICE
1518 WALNUT STREET
PHILADELPHIA 2, PENNA.
Telephone KIngsley 5-6650

September 2, 1947

Mr. M. N. Funk, Chairman
LATROBE PROFESSIONAL FOOTBALL MEMORIAL COMMITTEE
Latrobe, Pa.

Dear Mr. Funk:

Mr. Bell is out of town but has asked me to write to tell
you that the National Football League has agreed to help
support the Football Shrine. He would like you to come
to Philadelphia so that you and he can discuss the amount.

Mr. Bell will return to Philadelphia Wednesday, September
10th at which time you can arrange for a favorable date
on which to meet with him.

Sincerely yours,

Adele C. Ryan

Adele C. Ryan, Secretary

In this letter, Adele C. Ryan, secretary of the NFL, wrote Funk to tell him that commissioner Bert Bell agreed to donate funds from the league to help build the hall of fame in Latrobe. Unfortunately, in the 1940s and 1950s, the NFL never followed through on the pledge. According former Latrobe committee member Myers, "they pledged their support and were to set up a committee. Although they gave Dr. Brallier a lifetime pass to any NFL game, they never gave us any money." (Courtesy of the Latrobe Historical Society.)

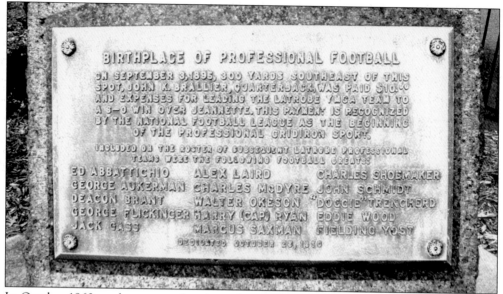

In October 1960, a plaque was placed at what would be the far gate of Latrobe's Memorial Stadium officially declaring the city to be the Birthplace of Professional Football. Celebrated on the plaque are the members of the 1895 club, which included Brallier. (Courtesy of the Latrobe Historical Society.)

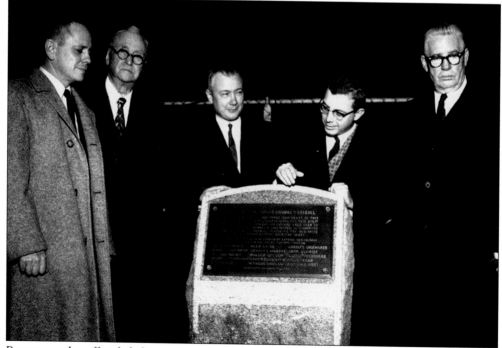

Present at the official dedication of the Birthplace of Professional Football plaque are John Brallier Jr., the son of Dr. Brallier; John Schmidt; Vic Staderek; E. Kay. Myers; and the chief, Art Rooney. The plaque placed outside Memorial Stadium is only 300 yards southeast of where the classic Latrobe teams of the 1890s played their first games. (Courtesy of the Latrobe Historical Society.)

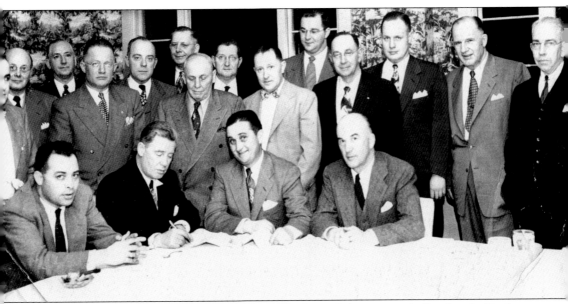

Gathered in Latrobe are several of the civic leaders of the city with Pittsburgh Steelers president and founder, Art Rooney Sr., seated second to the right in the front row. Standing behind Rooney and to his right is Brallier. Also present are several members of the Latrobe fire department with the department president, Joe Riley, seated to the chief's right. While Rooney was not able to help the city secure the football hall of fame, he was a staunch supporter of Latrobe and brought the Steelers to St. Vincent College for summer training camp every year, a tradition that still continues today. (Courtesy of the Latrobe Historical Society.)

There have been many honors for Art Rooney since his death in 1988. Two of the most prominent are the statue pictured above, which was originally located outside of gate D at Three Rivers Stadium and now sits outside of Heinz Field, and the street in front of Heinz Field that was named in his honor. Notice the "Gate D" sign that still remains today, the only section of the stadium not to be destroyed in the 2001 implosion. While Rooney was the city's greatest supporter in the NFL for Latrobe to secure the hall of fame in the early 1960s, former Latrobe Football Committee member Myers said that some of Latrobe's civic leaders felt the chief was partly responsible for the city not securing the bid, claiming he failed to push hard enough.

INTERVIEW WITH DR. JOHN BRALLIER BY PIE TRAYNOR

SPORTS PARADE---SATURDAY, NOVEMBER 17, 1945

MUTUAL NETWORK-ORIGINATION WIP PHILADELPHIA

PICK UP BRALLIER-TRAYNOR...KQV, PITTSBURGH

PROGRAM TIME: 5:15 - 5:45 P.M. (EST)

CUE: "WE TAKE YOU NOW TO PIE TRAYNOR AND HIS GUEST IN PITTSBURGH."

TRAYNOR: It's a privilege to join the Sports Parade today, as it celebrates its first birthday...and we are happy to salute a great American game which is also marking an anniversary...It's Professional Football, which has finally come into its own as a big-time sport after a small beginning more than fifty years ago- when a coach in Latrobe, Pennsylvania paid ten dollars for a young quarterback..... In the studio with me now is Dr. John Brallier, the quarterbakk for that team back in 1895... Tell me, Doctor, did you frame that ten dollars?

BRALLIER: No, Pie...I often wish I had,--but since I didn't realize the significance of that first payment, like most sixteen-year-olds, I *spent it on a girl!*

TRAYNOR: How did you happen to get paid?

BRALLIER: Well, in those days almost every town had a football team, and rivalry between them was pretty stiff-and a question of civic pride...The day before a big

After receiving the official designation as the first professional football player in history, Brallier was a frequent guest on many local radio shows. Shown here is a radio transcript from an appearance he made on Pirates hall of famer and third baseman Pie Traynor's "Sports Parade" on November 17, 1945. Brallier stated that he spent the $10 on a girl when talking to Traynor. In reality, Brallier spent it on pants as he prepared to attend Washington and Jefferson college that fall. (Courtesy of the Latrobe Historical Society.)

SEPTEMBER 28, 1951
8:00 P. M.

Latrobe High School
vs.
Donora High School

On September 28, 1951, the first piece of the Latrobe Football Committee's memorial project was put in place when Memorial Stadium was officially dedicated during a game between Latrobe High School and Donora High School. The stadium was built between World War II and the Korean War and was named a "living memorial to all those who served their country in time of war." The front end of the stadium was where the hall of fame was supposed to be constructed. Today a swimming pool sits in that spot. (Courtesy of the Latrobe Historical Society.)

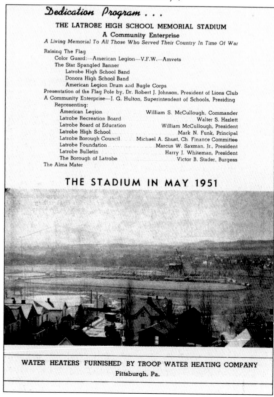

Dedication Program . . .

THE LATROBE HIGH SCHOOL MEMORIAL STADIUM
A Community Enterprise
A Living Memorial To All Those Who Served Their Country In Time Of War

Raising The Flag
Color Guard:—American Legion—V.F.W.—Amvets
The Star Spangled Banner
Latrobe High School Band
Donora High School Band
American Legion Drum and Bugle Corps
Presentation of the Flag Pole by, Dr. Robert J. Johnson, President of Lions Club
A Community Enterprise—J. G. Hulton, Superintendent of Schools, Presiding
Representing:

American Legion	William S. McCullough, Commander
Latrobe Recreation Board	Walter S. Hazlett
Latrobe Board of Education	William McCullough, President
Latrobe High School	Mark N. Funk, Principal
Latrobe Borough Council	Michael A. Shust, Ch. Finance Committee
Latrobe Foundation	Marcus W. Saxman, Jr., President
Latrobe Bulletin	Harry J. Whiteman, President
The Borough of Latrobe	Victor B. Stader, Burgess

The Alma Mater

THE STADIUM IN MAY 1951

WATER HEATERS FURNISHED BY TROOP WATER HEATING COMPANY
Pittsburgh, Pa.

Memorial Stadium in Latrobe is one of the products of the Latrobe Football Committee's fundraising efforts in the 1940s and 1950s. The stadium is the home of the Latrobe High School football team and is part of a bigger recreation facility that the Latrobe committee planned. In the picture is the Standard Steel plant behind the stadium, about 300 yards away, which was built on the site of the original playing field in the 1890s, the home of the Latrobe club football teams that were so important to the history of the game. (Courtesy of the Latrobe Historical Society.)

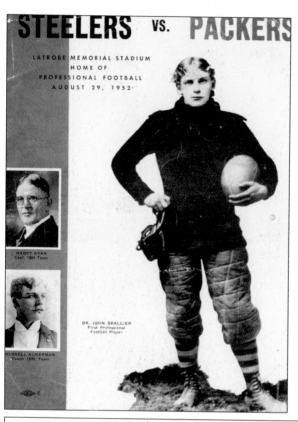

STEELERS VS. PACKERS

LATROBE MEMORIAL STADIUM
HOME OF
PROFESSIONAL FOOTBALL
AUGUST 29, 1952

HARRY RYAN
Capt. 1895 Team

RUSSELL AUCKERMAN
Coach 1895 Team

DR. JOHN BRALLIER
First Professional
Football Player

In an effort to raise money to build the professional football hall of fame and community center, Latrobe hosted an NFL preseason game with the Pittsburgh Steelers facing the Green Bay Packers in 1952. Shown to the left is the program of the contest featuring Dr. Brallier, Harry Auckerman (coach of the 1895 team), and Harry Ryan. An extensive story of Latrobe's football history and the quest to build the hall of fame are included in the program. The Steelers defeated Green Bay this evening 7-6 when Lynn Chadnois took a pitch from Ed Modzelewski and rambled 51 yards for the winning score. (Courtesy of the Latrobe Historical Society.)

SECTION ... **E**	**Latrobe—Home of Professional Football**	SEC. **E**
ROW **3**	PRESENTS **PITTSBURGH STEELERS** Friday, August 29, 1952 8:15 p.m., D.S.T.	ROW **3**
SEAT **23**	LATROBE MEMORIAL STADIUM	SEAT **23**
	GREEN BAY PACKERS	
PRICE—$6.00 PITTSBURGH STEELERS vs. GREEN BAY PACKERS	RESERVED (no refunds) — EST. PRICE ... $4.62 CITY TAX46 FED. TAX92 Total ... $6.00 GRAND STAND	Sponsored by the LATROBE VOLUNTEER FIRE DEPT.

Brallier's son, John Brallier Jr., shows off his father's old Latrobe football pants to a group of admirers. Unlike today's football pants, these had only small quilted pads and were made mostly of canvas. (Courtesy of the Latrobe Historical Society.)

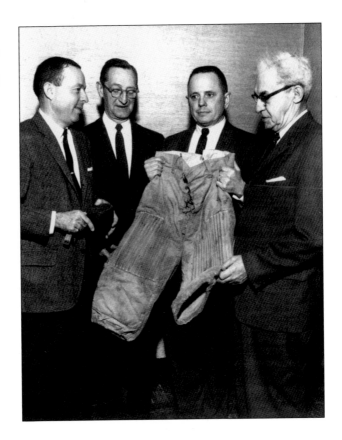

Besides being an important part of professional football history, Brallier was a successful dentist in Latrobe and was also a charter member of the Westmoreland County Dental Society, which he belonged to for 39 years, from 1911 to 1950. (Courtesy of the Latrobe Historical Society.)

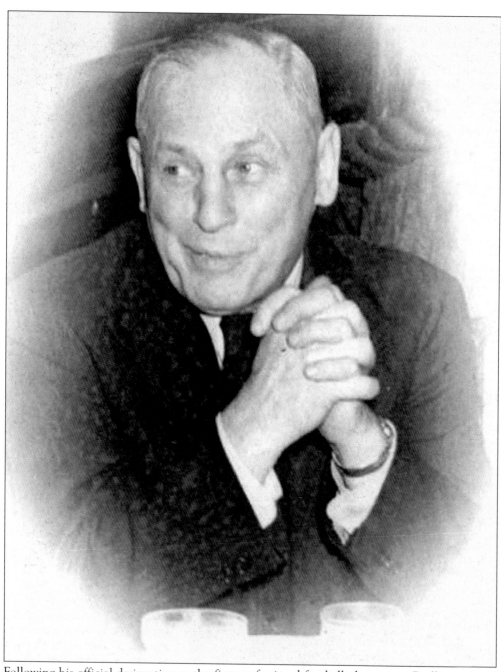

Following his official designation as the first professional football player ever, Brallier enjoyed his status around the area and the country. Brallier made many appearances not only to tell his story but also to support the Latrobe Football Committee's fundraising drive to build the hall of fame. Myers, member of the committee, tells the story of Brallier during his later life. "Dr. Brallier would often drop kick a football over his house for the kids, and he had a tall house. It was amazing to see a man that age be able to kick a ball so far." Brallier passed away in September 1960, still believing that he was in fact the first professional player ever. It was years later that proof to the contrary emerged. (Courtesy of the Latrobe Historical Society.)

Charles McDyre, the tremendous left defensive end for Latrobe, was also one of the last surviving members of the historical 1895 club. In his later years, McDyre was a frequent visitor to the team's reunions and hall of fame benefits. (Courtesy of the Latrobe Historical Society.)

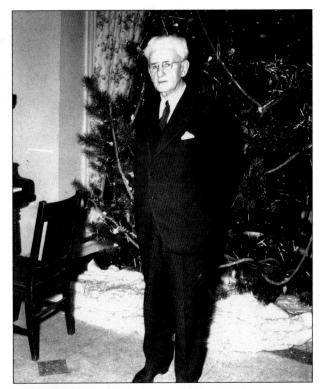

Harry Ryan was not only one of the most popular and one of the best athletes to play for the Orange and Maroon, but he was the first head coach ever for Latrobe High School. Besides being a Latrobe legend on the gridiron, Ryan played for West Virginia University and professionally for Philadelphia in 1902. He died in July 1953 after a long illness. (Courtesy of the Latrobe Historical Society.)

Carl Mattioli is the true keeper of the flame when it comes to telling the story of Latrobe's place in the history of professional football. Shown here holding the actual official declaration by the NFL giving Latrobe its status as the Birthplace of Professional Football, Mattioli, who heads the Latrobe Historical Society, has a vast knowledge of the city's football exploits during that time period. He also is well versed on Latrobe's failed venture to secure the hall of fame. "The forefathers of Latrobe sat on their rear ends too long. They kept asking where are we going to get the money. The money would have been there, if somebody had only followed through. Nobody followed through though."